THE PHOTOGRAPHER'S GUIDE TO MARKETING AND SELF-PROMOTION

Maria Piscopo

Third Edition

ALLWORTH PRESS
NEW YORK

05 04 03 02 01 5 4 3 2 1

Published by Allworth Press
An imprint of Allworth Communications
10 East 23rd Street, New York, NY 10010

Cover design: Douglas Design Associates, New York, NY
Cover Photo: Stephen Webster/Photonica
Page composition/typography by Celine Brandes, *Design Dimensions*

Library of Congress Cataloging-in-Publication Data:

Piscopo, maria 1953-
 The photographer's guide to marketing and self-promotion/Maria Piscopo.— 3rd ed.
 p.cm.
Includes Index.
ISBN 1-58115-096-2
 1. Photography—Marketing. 2.. Photography—Business methods. 3. Commercial
photography. I. Title.

TR690.P54 2001
770'.68'8—dc21

 2001033487

Printed in Canada

Table of Contents

INTRODUCTION

WHEN I WROTE MY FIRST MARKETING BOOK, IT WAS A SIMPLER WORLD. NOW, you'll find that many things about marketing photography services have changed. From the type of clients to working with stock photography to the technology of the marketing process, it's a different world. This edition also adds topics such as the consumer (wedding/portrait) clients and Internet marketing.

The biggest change is in the scope of the meaning of the term "photographer." Primarily, new technology and clients' need for speed have been driving this change. Digital equipment and client requests have motivated photographers to become illustrators, imaging experts, art directors, designers, and pre-press services; now everyone is a consultant of some kind! This is not good or bad; it is what you do with the technology and new clients that will determine the outcome. Just because something can be done does not mean it *should* be done.

If you are just starting out, congratulations! You have the advantage because you are not thinking of the ways things used to be. If, like so many of us, you have been in the business awhile, stop waiting for things to "get back to normal." Many of you in business for ten, twenty years have this feeling that "they" changed all the rules, and nobody called to tell you! There are new rules and business practices and this edition will present them, along with interviews from other photographers.

If you went to photography school last year or two decades ago, you learned how to produce images-perhaps in a darkroom, maybe in PhotoShop. With few exceptions, schools don't address the business aspects of "selling yourself." Even professionals who have been in business for many years have been caught unprepared by the new economy and marketplace. The thousands of photographers who began and ran their businesses by referral and word-of-mouth are being forced to re-evaluate their strategy.

I first became involved with the teaching of the business of photography as a faculty advisor at Orange Coast College in Costa Mesa, California. One of the first photography departments (thank you, Rick Steadry!) to devote a full semester strictly to a business class, it is unique in dealing with the buying and selling of photography services. Though general business classes can be taken in the business department of any college (and they should be), there are many issues particular to the photography industry that make a class like this necessary in today's new marketplace. Now I teach at six local colleges!

The OCC class led to my first book, seminars and workshops around the world, and a call from Turner Video Communications of Newport Beach, California. The most wonderful Mary Kathleen Turner moved a reluctant mountain (that would be me) to work with her to produce a series of four videotapes showing and describing everything I know about self-promotion. She's the best!

While I am on the topic of people I need to thank, I would like to acknowledge the people who have helped or guided me these last six years. I would like to thank Patrick Doyle and his son First Doyle. Also, Bill and Arlene Doyle and the entire Doyle Clan for making me feel once again like a daughter and a sister. Also, I am blessed with an extended family that includes my inspiration and my niece Danielle Mitchell, Cindy and Tom Brenneman, John and Lynne Bernat, Myra and Chip Allen, Debbi and Robert Brown, Tina and Walt Bayer, Rick and Paula Thues, Tom and Nancy Doyle, Joe Doyle and Coni Edick, John and Leslie Connell, Nancy Clendaniel, Theo Clark, Jeff and Madison Clark, the lovely Anette Hensley, Isaac and Karen Howard, Chuck and Janel Mitchell, Tony and Paula Luna, Kim and Chris Shettler, Stan Sholik, Roger Ressmeyer, Sam Merrell, Michael Furman and Adam Hoffman, Bob Atkinson, Annie Proffit, Len Vucci, the incomparable Cathy Valdez, and the Reverend Dr. Jim Schibsted.

Special thanks to Stephen Webster of the Worldwide Hideout for the outstanding book cover artwork.

Now then, this book is really a celebration for the next generation: Maranda, Nathan and Graham, Michael and Alicia, Desiree, Heather and Jacob, Lile, Max, Ryan, Amelia, Jessie, Dani, Katie and Samantha, Brett and Meagen, Cynthia and Carolyn, Lauren and Warren.

Finally, I want to dedicate this book to the memory of photographer and long-time friend, Ron Hussey. Ron, I know that you took off in that "Big Yellow Taxi" a lot sooner than any of us expected. It came for you and you left us, but I will always remember what Joni told us,

> "Don't it always seem to go
> That you don't know what you've got
> Till it's gone.
> They paved paradise
> And put up a parking lot. . ."

The best illustration of this change is in the strategy necessary for obtaining photo assignments. Twenty, fifteen, ten, even five years ago, you could go out with a portfolio and a business card and get work. Now you need many different levels of self-promotion to reach clients, to help them understand what you can do for them, and to remind them of it until they have an assignment for you! Though portfolio presentations have not become extinct, a good marketing plan that includes new electronic and Internet self-promotion tools is the best way to get work. Getting and holding the client's attention has become the true challenge of the marketing and promotion of photography services.

Money alone is not the key to self-promotion. "Plan the work, then work the plan" will be the solution, not how much money you have. Whether you have $500, $5,000 or $50,000 to spend on self-promotion, the rules and techniques are the same. At the high end, you are going after bigger clients with better budgets. At the low end, you could be just starting out, going after low-budget clients or trying out a new style on your current clients. Whatever the goal, strategy comes first. What are you selling? Who buys it? How can you best reach these clients? Then you'll be able to determine your budget.

I'm always asked when I speak at photo conferences, "Do these techniques work?" and my answer is always the same. "They work when you do." The key to self-promotion (and maybe to even being successful at anything you try) is to incorporate it into your day-to-day life. *The worst time to start a marketing plan is when you have the leisure time for it* — then it's too late, because you have no money! Everything in your marketing plan must be cross-referenced to your daily calendar. This book will teach you how to make self-promotion an everyday event, not something you do when there is nothing else to do and you are desperate for work.

Probably the other biggest problem to overcome is the tendency to do "shotgun" marketing. A mailing here, an ad there or a Web site out there all by itself is not a marketing plan. The marketing plan you write when you are finished reading and using the material from this book will help you avoid this problem. With a written plan, you can always ask, "Does this fit into my strategy?" whenever an opportunity to promote yourself comes along. The plan will guide you much as a map guides you to a destination, leading you from your first mailing through your well-designed Web site.

Think about it. Two photographers have to reach the same destination. It is in an unfamiliar and unknown location. One has a map to guide him and the other is told, "Go west and you'll get there eventually." Who gets there first? You know the answer. The map is the key. The marketing plan you write is the key to unlocking your success.

Chapter 1

THE BUSINESS SIDE OF SELF-PROMOTION

N O MATTER YOUR AREA OF PHOTOGRAPHY, TODAY YOU MUST DEAL WITH A permanent change in the photography industry. Simply put, you can no longer be just a photographer. The future belongs to the owners of photography businesses, so if you have recently said to yourself, "All I really want to do is be a photographer," you need to reexamine your objectives. Whatever the plan for marketing and self-promotion you write, you must deal with the business side. Here are four factors on the business side you need to get control over before you can be successful with the tools and techniques of promotion recommended in this book.

#1 GOAL GETTING

Setting goals is too passive an exercise to ensure the success of your marketing plan. Owners of photography businesses need to plan for success and not wait for it to happen. You need to *get* goals, not just set them. The key to successful goal achievement is to write it down. Your subconscious simply does not recognize the unwritten goal. Putting your desires onto paper creates an

unrestricted flow of energy and dedication toward achieving those goals. Yes, that may sound a little strange, but what could you possibly lose by giving it a try? Nothing! You can only win. Use this goal getting outline for your business and marketing goals:

State Your Objectives

These are the things you want to achieve. Write down all of them—big ones and little ones. Keep adding to this list. Even though you won't take action on everything at once, it's best to have a clear picture of what you want from your business. Be sure to use action statements such as, "I want to sell $150,000 of photography services this year" and not vague statements such as, "I want to be rich."

Actions Required

Decide which of the objectives on your list you want to achieve right now. Pull them out of the list and add the activities required for their accomplishment. Be sure to be specific and break down these activities into "bite-size" pieces. For example, one of your goals might be to hire a marketing coordinator. Break that down into: write job description, find place to advertise the job position, write ad, etc. This should be a step-by-step outline of tactics, describing how you will achieve your current goals.

Assign Resources

Next, add to each of the above tasks information regarding the time, energy, attention, and money they will require. Overall, you will need a marketing budget for the business and some of that can be applied toward specific goals. Typical marketing budgets for photographers are 10 percent of your projected gross sales.

Schedule Everything

Finally, take your daily calendar and schedule all the tasks listed above. You can always reschedule if a paying job comes along. This way, accomplishing any of your goals becomes a daily activity and not something you wait to find the time to do.

#2 DISCOVERING TIME

You know that any activity expands to fill the time allotted to it. So, unless otherwise managed, your day will fill up with what is in front of you rather than the business that needs doing. Because of this, you want to set aside the time to do everything you need to do (managing the business) want to do (goal getting) and have to do (photo assignments). The time is there. All you have to do is discover it.

Time can be buried in a number of different ways. Any of these sound familiar? *It's fun* — you give priority to tasks that are agreeable and then have no time left to do the less enjoyable but very necessary chores because your day is "full." *It's easy*—different side of the same problem. By doing all the easy things first, you bury the time for the bigger and harder jobs because you are waiting for the "right time." *It's here*—when you do whatever is in front of you without regard to priority or level of importance, half the day is "gone" and you don't know where it went. Now that you are aware of how you bury the time, let's look at how to discover it.

Use Your Calendar to Manage Time

Take your marketing plan (chapters 20 and 21) and your goal-getting plans above and transfer every item from both into your daily calendar. Be sure each item is specific and manageable (bite-size tasks) and be careful to allow enough time for each one. Do you know how long it takes to pay bills? Process the daily mail? Write a press release? You'll find out quickly. Don't forget to plan for your vacations and holidays!

Handle Work Immediately or Schedule It

As things come to your attention during the day, handle them immediately and completely *or* schedule the handling of them. For example, the Jones family calls you to request a family portrait and they want "something different" for an outdoor location setting. It's not a rush job. Rather than drop what you are doing that moment to scout the location, use your calendar to identify the next available time to scout a location. Everything goes on the calendar. No more lists of things to do!

Create a Tickler File

You'll need this important time-management tool to work with your calendar. Put together a file of thirty-one folders numbered #1 through #31. This is called a tickler file. Though there are computer programs (see chapter 19) to help you handle this task, there are usually still pieces of paper to keep track of! With a tickler file, as each paper crosses your desk, you have a place to put it. In the example above, you find some time on July 30 for the scouting; you'll write "Scout Jones location" on your calendar for July 30; and you'll put all the paper information pertaining to this in the folder numbered "30." No more piles of paper!

The key to this method is to handle everything you touch only once. Then deal with it immediately or schedule it. This will not only help you find more time but will do two other things important for your photography business. One, instead of waiting to find the time for marketing and management (you never will), you simply make them daily chores. Two, instead of getting

depressed when you have a blank calendar, you will always have something on your calendar to work on that will help you move toward business success.

Ira Gostin, Gostin Photography, *www.gostinphoto.com*, comments on both the importance of a business attitude and time management: "For me, the most important thing I learned was setting up my business initially like a 'real business' and not acting like a guy with a camera. I developed a team, and then attacked such issues as business license, sales tax, assistants, and procedures all from the start.

> **"For me, the most important thing I learned was setting up my business initially like a 'real business' and not acting like a guy with a camera."**

"Another item that I have found to be very helpful is managing my time better. I do not usually book jobs on Mondays. Monday is my day in the office for scheduling, writing proposals (when they can wait), and general left-brain business functions. Getting this all out of the way on a designated day allows me to not worry about such matters the rest of the week."

#3 GAINING CONFIDENCE

If you study very successful business people, the one thing you will find they all have in common is a very strong, calm, sense of confidence. This confidence is made, not born. It comes from actions, from testing oneself and passing the tests. This is true for your photographic creativity and technical ability as well as your professionalism and business skills.

The most important thing to know is that you must not wait to feel confident before taking action. You will wait forever! No, it turns out that your feelings follow your behavior. In other words, acting with confidence and the resulting success will eventually bring the feeling of confidence to you. Don't wait to overcome doubt and fear before facing any business or marketing challenge. Accept that these feelings are part of the process of testing and passing. Anxiety and hesitancy may feel like negative feelings, but you have to look at them as indicators that you are doing something you haven't practiced. For example, the first time you quote a really big job or tell a client you can't shoot that job on her budget, you will feel some fear and anxiety. Don't worry! You are experiencing a perfectly normal reaction any business owner feels when being assertive.

After all, you only have three choices for a business attitude and you always make a choice of one, whether you are conscious of it or not. An aggressive attitude means you get what you want without care or concern for the other party. A nonassertive attitude means you give people whatever they want without care or regard for the cost to you (a common problem in quoting photography jobs). An assertive attitude is simply an approach to your business in which you get what you need and the clients get what they need. Being aggres-

sive could drive your clients away. Being nonassertive could put you out of business! Assertiveness may cause you some short-term discomfort, but will ensure you long-term satisfaction and profitability. The trick, of course, is to learn to accept the fear without waiting for it to go away and go forward to do the work. The most common technique for achieving this is called *visualization*. You must see yourself accepting the challenge, mapping a strategy to meet it, and then successfully accomplishing the task at hand. No matter what the situation, this technique works to create your success and the feeling of self-confidence that follows!

#4 DEALING WITH STRESS

Most stress in a photography business comes from trying to balance two conflicting needs. You need to be businesslike and you want to be creative. You need to dedicate yourself to your work and you want to spend time with your family. Sound familiar? You could probably write an endless list of personal and professional conflicting situations. The important thing to accept is that this stress is normal. Distress, such as family illness or natural disasters, is not the norm and can't be managed the way stress can be. If you have determined that you are dealing with stress and not distress, try these simple rules.

Stop Trying to Get Caught Up

You'll never be caught up, so stop trying. There will always be a never-ending succession of business and marketing tasks as well as your photography work. Stop waiting for the in-basket to be empty. Stop anticipating feeling "caught up" with your work.

You Can't Control Other People's Feelings

You'll never make everyone happy. There will always be a photography client who will want you to feel or behave differently (especially when it comes to pricing). Stop expecting people around you to always approve of you or be happy with you. You can only do your very best to please your clients and run a profitable business. You can't control other people's feelings about you.

Worry Produces Stress

Worry is a great producer of stress. Have pen and paper handy so that you can write down any particular worry. Put it aside to be considered later (this technique is also called "getting it off your chest"). Often, the worry will resolve itself or is no longer so overwhelming. Newport Beach-based motivational speaker and author (see the excellent series of books, *Chicken Soup for the Soul*) Mark Victor Hansen calls this type of stress "stewing without doing" and it is very nonproductive. It will also help to read the book by Spencer Johnson, M.D., *Who Moved My Cheese?* You will discover that a lot of your worry is just

the normal process of your "cheese" moving from point a to point b (do read the book!).

Learn the Art of Saying No

Learn to say No. Often, stress is created when you say Yes, even though all logic and common sense tells you to say No. Pricing a photography job is a perfect example.

One of the most valuable business techniques to learn is to share with the client the costs of changes he wants to make instead of letting the cost come out of your fee. This most often comes up when you have a client make a request on a job that you cannot fulfill without loss of profit (don't forget, even time is money). Whether clients want more shots, more props, or more revisions to a digital job, when you respond "Sure, okay, fine, no problem," you set a very bad precedent, perhaps a costly one! Of course, cost here does not only mean money. Cost on any photography project can mean time, stress, energy, attention, quality, or money.

> "Cost on any photography project can mean time, stress, energy, attention, quality, or money."

Try one of these three options, "No, *but* here's what we can do (name some other option)"; or " Yes, *and* that will cost (come up with something specific)"; or, just simply, "Let me get back to you!" In each case, you have presented further considerations that will reduce the stress of saying Yes when you mean No.

Chapter 2

GETTING STARTED IN BUSINESS

WHEN YOU ARE JUST STARTING OUT, IT IS IMPORTANT TO FOLLOW THE STANDARD business instructions for financial and legal considerations. It is also good to work with a checklist that will help you plan for your start-up budget. Finally, at the end of this chapter, you will find an example of how to write an overall business plan.

FINANCIAL CONSIDERATIONS

Forms of a Business

Start by deciding on the form your business will take. Even a part-time business has to have some kind of structure. The three most basic forms to choose from are corporations, partnerships, and sole-proprietorships. Corporations may or may not have the many advantages they used to have, depending on what part of the world you live in!

For example, every state in the United States has different rules for corporations. The primary reason for incorporating your business when starting out is to protect your personal assets against liability. However, you are unlikely to

be in a situation making you that vulnerable. Other than injuring their aesthetics, by showing them photographs they hate, you can't hurt people that badly! Check with your personal accountant for the best time to incorporate for any tax advantages or other benefits.

Partnerships are not unusual in photography but you must start with a partnership agreement. Even if you have known the other person since childhood, differences and dissension later on may have a tremendous financial impact. Don't leave home without one! The primary reason you really need a partnership agreement is for the termination of the partnership—something no one thinks about at the beginning of a relationship. But the worst time to negotiate terms of dissolution is at the time you are splitting up. Partnership agreements are fairly standard legal contracts; so don't hesitate to investigate the cost of a consultation with an appropriate attorney. The most successful partnerships seem to be a joining of the two sides of the brain, left and right. If you have one business partner and one creative partner, the work is more easily split between you. One partner handles the photo assignments and the other runs the business.

Sole-proprietorships are the most common form of photo businesses. They are by far the easiest and least expensive to start and run. The downside is that you alone bear the total financial liability. The good news is that all the profits are yours.

Business or Hobby?

You will want to make sure that your photography business is set up to be a valid business entity. The Internal Revenue Service has a set of "hobby loss rules" to uncover tax abuses. Some people with a lot of expensive camera equipment will try to declare the equipment and expenses as a business depreciation or deduction when they are really hobbyists. This will lower their tax liability and that is what causes the IRS concern! Again, check with your accountant, but the main factors the IRS will consider are the separation of business and personal money in and money out (two checking accounts), the efforts to market your photography and any other sources of income. Being audited and declared a hobbyist by the IRS could cause the loss of your business depreciations and deductions. Since this will raise your income tax liability, you should be highly motivated to maintain all the forms of a real business.

Business Checking Account

This is the most important evidence of your seriousness as a business and essential for the accurate estimating of your income tax liability. This is the "Schedule C" on your Form 1040 income tax return and will be calculated from your business checking account. Keep your personal checking separate so the money in and money out of your business is clear.

Bookkeeping Journals

Good records are an essential part of starting a business and an important piece of evidence to the Internal Revenue Service that you are serious about your business. The most basic records are a Cash Receipts Journal (money in) and a Cash Disbursements Journal (money out). Always check with your accountant before deciding on the best bookkeeping system for you to use. It is best done with a computer software program. Whether the software is a stand-alone program or built into a photography business software program, check first with your accountant. Since he will be calculating your tax liability from these records, you want to be sure to use a software program he is familiar with—or you will pay much more for your tax return. See chapter 19 for information on business software programs.

List of Assets

Every business is allowed a maximum yearly deduction for new equipment or assets. After that, you will need to use a schedule of depreciation. Also, no matter when you purchased your car, computer, or photographic equipment, you can bring these "nonconsumable" and previously purchased assets into your business and depreciate them as a form of deduction against your tax liability. Check with your accountant as to how much you can depreciate over how long a period of time.

LEGAL REQUIREMENTS

Business License

When you live in an incorporated city, you are required by the city to obtain a business license, usually renewed annually. Find out if this is a calendar year or an anniversary year. Some cities also require a one-time permit for a home-based business. The business license is issued at your local city hall. Since every city is different, first find out what fees are involved and what proof of residency you need to provide. For photography businesses, city business-license offices are sensitive on two points. First, will your new business generate lots of foot traffic or need exterior signs? You may live in an area not zoned for either of these. Second, will your new business generate toxic wastes? Environmental issues dictate concerns over such things as darkrooms and chemical processing.

Fictitious Name

Your local county office will issue a Fictitious Name permit (or DBA "Doing Business As") when your surname is not used in your company name, such as "Mary's Photography Studio." *Caution!* If you plan to use a fictitious name, you will have to take this step first because most banks will not let you open a busi-

ness checking account without the permit in hand. You can go to the county office of fictitious names or use the filing services of your community newspaper.

Resale Number

When you start a business in a state that charges sales tax, no matter how small the business, you need to charge, collect, and pay the appropriate state sales tax on all your sales. You charge this sales tax to your client on the entire subtotal of your invoice. Contact the State Board of Equalization office closest to you for its publication on the rules and regulations in your state. For a low-dollar volume of sales, you will probably file and pay yearly. Most photography businesses file and pay sales tax quarterly. Remember: When you get paid for a photography job, the invoice total includes the sales tax. This is not your money! Find a way to set the amount aside on a regular basis so that filing and payment of the sales tax is not such a shock to your business checking account.

In addition, the resale number you are given can be used for resale purchases. This means you do not pay sales tax on items you purchase that will physically transfer ownership to your client. For example, you can use your resale number when purchasing photographic processing, but can't use it when buying equipment. Again, check with your State Board publication for the latest information.

Federal Identification Number

For the sole-proprietor, this is your social security number. If you become an employer or another form of business, you will need to apply for a separate identification number from the appropriate Federal office.

Business Insurance

The moment you start your business, whatever renter's or homeowner's insurance you had on your photographic equipment as a hobbyist is no longer applicable. You will need a separate business insurance policy for your equipment loss or damage as well as personal liability insurance. This "studio insurance" package can be purchased from any insurance company or at a discount through membership in one of the professional photography associations that offer this benefit.

BUDGETING FOR A START-UP OFFICE

Phone and Fax

A business phone number is essential to doing business today, so you can be picked up in the telephone directory's business listings. With today's technology, one phone line can serve multiple functions of voice, fax, and modem.

Answering Machine

Consider a telephone answering system that allows the use of one telephone number that connects your voice mail, fax, cell phone, e-mail and can be accessed from any phone as well as your computer.

Computer

Many photographers use one computer for the business management and marketing and another computer for their digital imaging. See chapter 19.

Marketing Materials

Be sure to account for all the costs of starting a photography business, including marketing materials—from logo design and printing to portfolios and promotions.

Sourcebooks

Don't forget to buy sourcebook directories for research (chapter 11) and to pay your association dues (chapter 7). You may even want to write your marketing plan before committing to a final start-up budget!

Office Improvements

Plan ahead before proceeding with any office or studio improvements. Even if the addition or expansion is not immediate, better to plan for the expense when you have the money to pay for it!

Security

Don't forget about automotive and studio security systems. These can lower your insurance costs and save tens of thousands of replacement dollars in the event of loss or damage to property.

WRITING A BUSINESS PLAN

A written business plan is an essential part of the legal and financial planning of a business. It is useful for managing an overview of your business and your long-term goals. It is essential if you are looking for financial assistance.

A written plan will give your new business focus and direction and help you to identify the marketing you will later plan for (see chapters 20 and 21 for writing a marketing plan). There are dozens of formats for writing a business plan. Check with your local Small Business Administration office for its publications on the subject. Another option is to make an appointment with a SCORE consultant, a division of the SBA. SCORE (Service Corps of Retired Executives) offers free business consultations on any subject—including writing a business plan!

This particular plan is written in four parts and it is most useful in outline form. The average length is from one to three typed pages.

BUSINESS PLAN OUTLINE

1. Stating Your Marketing Message.

Answer the question, "What do you want to do more of and who buys it? "It is important to understand that it is normal business practice to target more than one market for your services. It's the old question, "Are you a specialist or a generalist?" The answer: Both! Ultimately, clients will always hire you as a specialist in order to get exactly what they need and then use you as a generalist. It is the "safe" way for most clients.

So, to become a true generalist and build a strong business base, you must start out as a specialist with one focused marketing message directed to your prospective clients. What do you want to do more of? To remain a profitable and recession-proof business, you should develop multiple profit centers. Each profit center requires a different marketing message.

There are four ways to identify your marketing message. They are style, subject, industry, and use of the images.

- By a particular *style* of work

This is based on how you "see" the world. Selling style is selling your personal vision, which tends to be used by high-end clients or clients in cutting-edge industries such as editorial or entertainment. Style is based on your personal creativity. It takes a very confident and secure client to go with your personal style instead of taking the safe, conservative route!

- By naming a *subject*

This is based on what you are shooting, and it is the most common approach to marketing and self-promotion of photography. Both consumer and commercial photographers use this one successfully. It could be the photography of people, products, architecture, and nature—any subject you can name! If you need help with this, check some of the stock photography agency Web sites and see how they sort images by subject.

- By a specific *industry*

Here the message is based on who buys the photography. This is a good marketing tactic because it makes it so easy to identify clients. Almost all business resources (see chapter 11) are organized by industry or standard industrial classification codes. It also helps clients to know you have experience with their product or service. For example, once you have done work for a financial firm, you can sell your experience and expertise in the industry to other financial companies.

- By the *use* of the images

This is based on how the photography is used; for example, annual-report photography or catalog photography. This targeting works well because it also makes it easy to identify clients.

2. External Evaluation of Your Strengths and Weaknesses.

These are external factors of business you cannot control, such as the length of time you've been in business, the economy, the competition, the weather, and so on. A careful analysis here helps you determine your chances of business success in your current situation.

3. Internal Evaluation of Your Strengths and Weaknesses.

These are internal aspects of business you can control such as your business skills and knowledge, your start-up budget, your bookkeeping software, your technical skills, the equipment you need, and so on. They should be items other than your marketing efforts, such as portfolio and promotion, since you will be planning for those items when you write your marketing plan. Take your time with this step. These are all factors you have the power to take charge of and work on to increase your chance of business success.

4. Setting Objectives and Tactics.

What tasks must be accomplished to strengthen the weak areas listed in the third section? Be very specific and list or state exactly what you will do. Next to each task, plan your timeline of what you expect to accomplish and by when.

David G. Rigg Cr. photographer. F-PPC, PPA Certified, director of marketing, Sandra David Fine Art, Inc., *www.SimplytheFinest.com*, wraps up this chapter by looking ahead. David says, "We will touch thousands of lives during our careers and most of them will never even remember or know who we were. But we will have created for many the only legacy that they will have—their portraits. Will your business be your legacy? Will you lie on your deathbed and yearn for the feel of the camera in your hands one more time? Or will you regret the trips you never took, or the birthdays and soccer games that your children had without you because you had to shoot a wedding because you needed the money! Think about how you want it to end. Chances are it won't work out exactly as you had planned, but you will be so much better for having had not only a plan for your business, but a plan for your life."

> "...we will have created for many the only legacy that they will have—their portraits."

Chapter 3

ADVERTISING AS A MARKETING TOOL

A DVERTISING IS ONE OF THE BIGGEST EXPENSES IN YOUR BUDGET FOR SELF-PRO-motion. Before buying any print or electronic display ad space, let's look at some of the factors for successful advertising.

WHERE TO ADVERTISE

Start with getting all the free listings available to you as a photography business. Every trade association has reference books that will sell you display ad space and many offer free (or low-cost) information listings. Also, don't overlook your own industry-photography! Get your free listings in both the online and print creative sourcebooks that offer this valuable benefit. For a listing of sourcebooks, check *The Workbook Directory* under "directories." *The Workbook (www.workbook.com)* is an industry sourcebook that maintains a phonebook-style directory of resources—including other sourcebooks. The list of online addresses is constantly being updated so you need to search for the current ones.

For your display ad space purchasing, start with a profile of the client you

are trying to reach with your advertising. Ask a select group of your potential clients what publications, annual directories, and Web sites they look at. Then, ask them which ones they use on a regular basis *to find photographers*. Just because clients have annual directories around the office doesn't necessarily mean they use them to find photographers! When you visit clients' offices, make a note of the publications, CD-ROMS, and sourcebooks you see on coffee tables and desks. Or, use a phone, e-mail, or mail survey with a fax back or postage-paid response to your target audience to reach an even larger survey sample. Try a survey on your Web site's guest book page. It is important to find out what sources your potential clients use to find photographers.

WHEN TO ADVERTISE

The decision to advertise is often made when your client profile tells you that your pool of potential clients is so large that traditional direct mail and selling techniques will not reach all of them at once. This does not exclude direct mail or selling, it just means that you need to start marketing by "broad-casting" your message (either in print or on the Internet).

You also know you are ready to consider advertising when your marketing message (chapter 2) is very clear and focused. For a strong, visual style that is distinct for its uniqueness, a sourcebook print ad (either regional or national) is a great option.

When you have a subject-specific message (i.e., food photography), a trade publication or local sourcebook may be more appropriate to consider.

It is very important to make a strong and immediate impression by showing one marketing message per ad. So, when you have multiple specialties or marketing messages, you may need to consider separate ad campaigns.

Contact publications or sourcebooks and get their "media kits" for information. As a prospective advertiser, you are the client. Look for display ad purchases that include or make available the following: listings in their annual directories and on their Web sites, reprints of your ad in the publication, and access to their mailing list either on labels or on a CD-ROM.

Stock photographer, John Kieffer of Kieffer Nature Stock, *www.kieffernaturestock.com*, has used several forms of advertising for his stock photography business and says, "Over the years, I've been in many national and regional directories and have sent out plenty of printed promo pieces with varying success. What I learned early on and is still true today is that photo buyers look for a specific image

> **"What I learned early on and is still true today is that photo buyers look for a specific image and then request it."**

and then request it. Therefore, you really have to get many images in front on them, like a catalog. They don't like to request a general submission and, in reality, no stock agency can afford to hire someone to "pull" and then re-file great quantities of film from the general stock files.

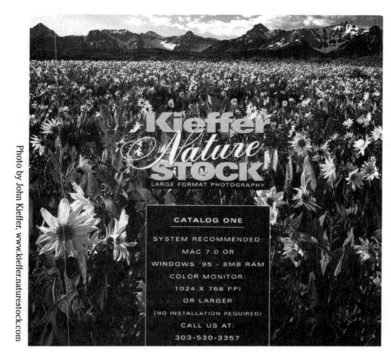

Photo by John Kieffer, www.kieffer.naturestock.com

Figure 3-1

"By far our greatest success has been through the distribution of CD-ROM stock photo catalogs that we produce in-house. We can't afford a large print catalog, but the CD-ROM allows us to present several thousand images in a stock catalog format (figure 3.1).

"We've developed a certain niche in the marketplace and when clients receive one of our catalogs, they know it provides some depth in the subject. Take, for example, our CD catalog of "Colorado and the West" photos (figure 3.2). Duplication costs are very reasonable, so the CD is sent out free, just like a print catalog. In some ways the Web is so passive. By using CD-ROMs, I can actively go after clients I know use our kind of photography. We've noticed that CDs are held onto and passed around, not thrown away. So they provide good sales for years. CDs also allow the user to download a low-resolution file. The result is that when someone calls about usage fees, they've already invested many hours with our image and it's been approved. This provides greater bargaining power when discussing price."

John also comments on the difference between his experience with CD-ROM and Internet use as an advertising tool and the results he has seen. Remember that your advertising media choices will predict the types of clients who respond.

John says, "The people in the business who receive our CDs tend to respect copyright. It's not like the Web, where your photography is available to anyone and lots of them don't know anything about copyright. Very few photographers have taken advantage of CD-ROM technology, as

Figure 3-2

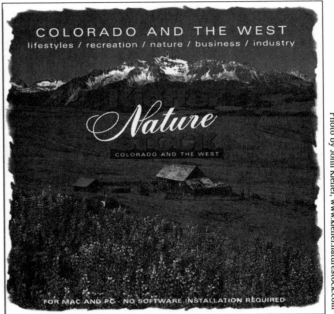

Photo by John Kieffer, www.kieffer.naturestock.com

the big stock agencies have done. Consequently, when we send them out, we are perceived as a larger stock agency. We have considerable Web technology available to us, but our Web results have been relatively poor. One thing is clear: Our sales made over the Web have been to lower-end clients with small budgets and can be rather frustrating."

DESIGNING YOUR ADVERTISING

There are two approaches to designing your ad campaign. One, you want to keep your name recognition at the very high level you have established (*image advertising*). Two, you want to sift through the clients your ad will reach and identify the ones interested in working with you (*response advertising*).

Once you have decided that a response ad campaign is appropriate, sit down with your art director or designer to review the checklist below for thoughts on how to increase the response to your ad campaign.

- Decide on the response goal. Unless you have a well-established name and marketing message or style to maintain with an "image" ad, be sure to design your ad with an eye toward soliciting a response. After all, if you don't, then you are just showing pretty pictures. Make the response mechanisms (how they can reach you) attractive and easy to use. When you create an ad that compels clients to inquire, you have a response device that will filter a large pool of potential clients down to the few interested ones.

- Determine what makes you or your images special. It could be a style, a philosophy, your personal background, your cultural awareness, the location of your studio, or even the ad concept itself.

- Plan for frequency. Your ad will need anywhere from six to sixteen exposures to your clients before they will recognize your message. Recognition builds response.

- Add credibility to the ad design with client testimonials, quotes, job references, or association memberships. All any client knows for sure about you is that you found the money to pay for the ad!

- Include a sense of yourself and what you might be like to work with. Ads are an impersonal medium of self-promotion and need to be warmed up with a personal identity clients can relate to. A self-portrait, such as the one here of John Kieffer, which visually repeats your marketing message, would be perfect to include in a campaign design (figure 3.3).

- Always think in terms of a campaign, not just an ad here or there. Advertising is a long-term commitment toward building an image in the minds of your potential clients.

Figure 3-3

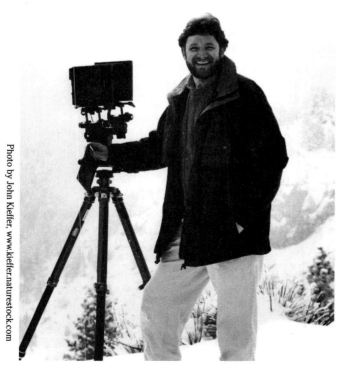

Photo by John Kieffer, www.kieffer.naturestock.com

IMAGE-SELECTION CRITERIA

The crucial part of any ad campaign will be the selection of images used to illustrate your marketing message. Here are some tips to review with your art director or designer.

Images Should Be Subject-Specific or Illustrate Personal Style

Most ads fall into one of two categories of marketing messages. One is a subject-specific marketing message such as, "Call on us for your architectural photography needs" and selects images in just one subject area. Remember: You are advertising for the work you want to do more of (architectural) not the work you already do (everything). The second marketing message projects your personal style or vision. These images will not be specific to any subject. In fact, it is important to show a variety of subjects as long as they are consistent in their style. Here, your marketing message is, "Call on us when you want your images to look like this."

Make Use of Your Own Personal Style

Show the everyday subject in an extraordinary way in order to motivate the client to call and inquire. Take any given subject—food, people, architecture—and shoot the most creative and technically challenging images. Your objective is to get your client to stop turning the pages of the publication or sourcebook and study your images and decide on his response. You want to create images for your ads that prompt clients to ask themselves, "How did they do that? I need to know!"

> "Show the everyday subject in an extraordinary way in order to motivate the client to call and inquire."

Show Your Expertise

Don't be too concerned when you discover a gap between what you show and what you do get as far as the type of work the client is looking for. Very often, your ad will move and inspire clients to call even when they do not have exactly the type of work you show in your ad. They simply want to work with a photographer who can do that level of work. Hopefully, they will have a future need for your style, but at least you have the start of a client relationship.

Above All, Be Creative

Finally, work with the most incredible creative team you can put together and don't forget the advertising copywriter. Be sure to adapt, not adopt, when looking at other photographers' ad concepts. Don't copy! Be creative about how you and your team create your ad campaign.

Chapter 4

DIRECT MAIL MARKETING

IN EVALUATING THE EFFECTIVENESS OF YOUR DIRECT MAIL MARKETING CAMPAIGN, YOU will apply some of the same criteria that you used for your advertising. Both are forms of nonpersonal marketing. The advantage of direct mail marketing is that, unlike advertising, it is "hand delivered" to your clients and prospective clients.

With direct mail, the audience you can reach is limited by the number of pieces you can afford to print and mail. Direct mail works best in a complete marketing campaign where your ads expose a very large pool of clients to your marketing message and your direct mail carries that message to a smaller pool of clients pulled from the larger pool.

To build up your mailing list (see chapter 11), you can use any of the industry-specific sources for leads for your mailing. If you are buying this information, look for individually prepared lists targeted to your marketing message. Make sure the company updates its database at least three times a year. If you buy the database, make sure you can add your own names and use it to mail/merge for custom letters and envelopes. Check out the search and sort capabilities (take a "test drive" if you can!). Finally, check on the delivery mechanism, as there are

now many choices. You can still just get labels but you can also check on electronic delivery to use the database on your computer or to import the data into your existing contact management software.

DESIGN CRITERIA

Here are the ten important "response" points to review with your designer when creating your direct mail marketing campaign.

Decide What Kind of Response You Want from Your Client

What is it exactly that you want people to do when they receive your mail? How many response choices can you give them? There is no limit to the possibilities. They can range from a very passive or low-risk response, such as "Wait for our next mailing," to a very aggressive or high-risk response, "Call when you have a job!" There is no right or wrong here, but you must be sure to match your response and risk factors. The lower the risk to your clients (or the more passive they get to be), the more people will respond. The higher the risk (or the more proactive they have to be), the lower the response. Again, both will work, but which one is right for your direct mail campaign must be determined by your overall marketing plan objectives. One factor to help you decide is the size of the mailing. On a very large volume of mail, you may want to use a high-risk response so you just get your serious photography clients to respond; that is, people who are ready to talk to you about an assignment. If your mailing list is very small, you may want as many people as possible to inquire, so lower the risk!

Make an Offer They Can't Refuse

The usual offer, "Call for a Portfolio," has become pretty common. A client would have to be really interested to accept that offer and respond. If you want more response, be creative!

Make it Easy to Respond

Include the maximum number of response mechanisms on the printed pieces. It is important they be on the mailer itself so they are still there when the envelope gets thrown away. These are: firm name, your name (so they know who to ask for when they call or e-mail), full address with nine-digit zip code, area code with phone number, area code with fax number, e-mail address, and Web address.

Clients Should Be Able to Relate to Your Message

Clients should see themselves reflected in the copy you use in your mailings and be able to easily relate to your message. If the message is about you—not them—it is an obstacle to the viewer. For example,

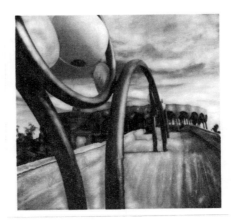

236 west portal avenue suite fivehundredtwo san francisco, california 94127 ph: 877-ken-ario (536-274

Featured
in the
Black Book 2000
pages 658-659

kenario.com

Figure 4-1

Ken Dorr and Mario Marchiaro, Kenario, *www.kenario.com,* did a wonderful job with the wording of the copy inside their invitation-style promo card mailer: "You are cordially invited to view Kenario's hand-manipulated, on-location Polaroid portfolio," and then asked clients to "RSVP" to their studio phone number or visit their Web site (figure 4.1). Ken Dorr comments, "Our monthly mailers are printed on classic velour, watercolor paper, and sent to 400 advertising art buyers around the United States. The response has been wonderful and gave our Web site quite a boost."

Make it Personal

Include yourself in your direct mail marketing and make it a personal form of a usually nonpersonal marketing tool. Consider any design technique that allows the client to get to know who you are: self-portrait, outtakes from shoots, personal philosophy, cultural background, a quote from you, and your personal signature. You can adapt these ideas or be creative. Ask yourself—what has not been done?

Provide a Motivating Deadline

Traditionally, giving a deadline to respond and receive your offer moves clients to respond. Without one, there is more of a chance that your mailing will go into a pile of "things to do" and never be seen again!

Make Your Direct Mail Interactive

Ask for clients' physical participation in your mailing with design elements such as perforations, die cuts—anything that allows them to be more proactive instead of simply opening your mailing. Get them interested, intrigued, involved. Not only will this increase response, but they are also more likely to show your piece to all their friends in the office.

Make It a "Keeper"

Maybe you want your mailer to be displayed in clients' offices. To reach this objective, you must design a "keeper" of some kind that has both form and function. A typical example is a calendar or photo frame. Think of this mailer as a mini-billboard your client will pass by every day in daily office activities.

Make it Believable

When your clients look over your mailer, they should feel they have something they must respond to or should keep and remember. This impression is made indelible when you cross-reference it to other marketing tools, such as a sourcebook ad. Kenario added text, cross-referencing the mailer to the company's Blackbook ad (figure 4.2) and Ken Dorr says, "We still hear from people who have kept the pieces and displayed them in their offices." Not only does this make them more believable mailers, but the cross-reference builds frequency of response.

Keep It Relevant

Be sure your concept and content are relevant! Do your homework so you will use the most appropriate design for your targeted client profile.

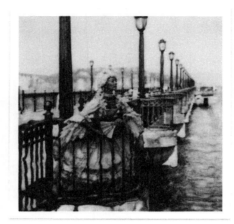

You are cordially invited to view
Kenario's
hand manipulated on location
Polaroid portfolio
Please RSVP at 415 664-6811
or visit www.kenario.com

© 2000 Kenario, www.kenario.com

Figure 4-2

Morgan Shorey, The List Inc., *www.thelistinc.com*, says "Design factors are critical but please sell photography with your direct mail, not someone else's typography or design. I like to use self-mailers (no envelopes). Check with your designer on getting gang-printing runs. Always use 'less than fussy' design applications. Keep it simple" (figures 4.3 and 4.4).

> **"Design factors are critical but please sell photography with your direct mail, not someone else's typography or design."**

Mark Gooch Photography

Figure 4-3

Atlanta
404-814-9969

New York
212-532-0077

Studio
800-964-6624
205-328-2868

Represented by Morgan Shorey

Mark Gooch Photography

Figure 4-4

Ira Gostin gives his design strategy:

My strength in my direct mail is a simple and direct design, using only strong images (figures 4.5 and 4.6). As a corporate photographer, I just want to present the images in a clean, straightforward manner. Also, I constantly stay in touch with clients via small notes, handmade note cards, little gifts, fun and crazy things I may pick up on the road. I like to let them know how important working with them is to me.

IMAGE-SELECTION CRITERIA

Again, like advertising, image selection is an important issue. Unlike advertising, there is a lot less pressure on the photographic image to carry the entire burden of the marketing message. Direct mail is usually a series of images, but you and your designer may decide to minimize or eliminate visuals and go with a clever all-copy mailer!

Ira Gostin describes his image-selection process this way: "To select the actual images for the mailers, I do some brainstorming with my 'creative group.'

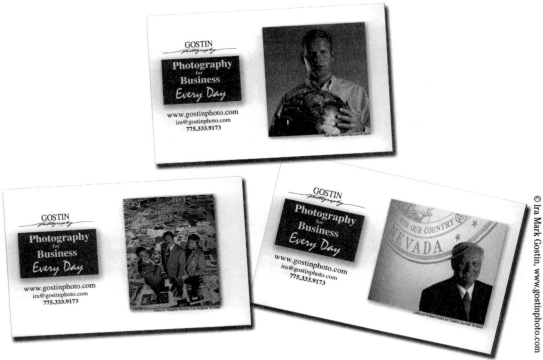

Figure 4-5

I put together a small group of friends: a client, a colleague and a mentor whom I will bounce ideas off of, all over e-mail. It has proved to be highly successful, and the comments I receive back have been extremely useful. As a result, I have also redesigned the response mechanism. I used to include a 'Fax-Back' response form, but I have stopped using it. Most of the art directors and art buyers on my list really do not use their response mechanisms anymore. I just keep a variety of contacts going out to them and then use my sales plan to follow up by fax, e-mail, or phone calls."

In selecting images for your mailing you must be careful to not to offer too wide a range of photos to prospective clients. Your marketing message (chapter 2) dictates your image selection and is targeted to the work you want to do more of! This is very narrow compared to the range of images you are actually capable of making. But you are not marketing what you *can do*; you are marketing what *you want* to do. (You may want to consider a separate campaign for current clients who are used to seeing a broader selection of your work.)

Morgan Shorey's experience as a rep and a database manager for The List supports this idea: "Image selection is easy to say but hard to do. The images must deliver on the mission or vision statement. If they do not, pull them out. Always use your marketing message as your measure."

Figure 4-6

If your marketing message is a visual style, then show it. Push it to the edge and show your style in as many situations as possible. Remember: Style is not specific to any subject! Shawn Michienzi, RIPSAW, inc., *www.ripsaw.net*, did a mailing of four "magazine"-style promos. His objective was to show a variety of work tied together with an appreciation and recognition of the RIPSAW style. His visuals are unique (figure 4.7), and his request for response is irresistible (figure 4.8). Both of these factors work very well in appealing to his target market-advertising photography.

Also, since many of you will have more than one marketing message, watch for crossover images for your direct mail campaigns. Crossover images allow you to use the same image for more than one target market. For example, a portrait of corporate executives may work in a direct mail campaign for both "people" photography and "annual report" photography for commercial clients as well as "portrait" photography for consumer clients.

PLANNING AHEAD

When you plan your direct mail efforts, design campaigns for spaced repetition and frequency. Be sure to schedule design and production timelines. Take

Figure 4-8

out your calendar and create a timeline working backwards from the date you want the pieces to be mailed.

Morgan Shorey adds, "Whatever your goal for your direct mail, regularity is the key. Decide and then follow through. Depending on your client base, mail monthly or every six weeks. I recommend you skip the months of July and December."

Ira Gostin adds this detail from his marketing plan: "I produce a printed piece on the average of three times a year, and mail to a general list we have created. Then, on a monthly or so basis, I market to my 'short list.' This is a series of lists, one for each different market and each having its own marketing message, with about twelve names on each list. Each short list is specifically targeted and the people on the list will receive a variety of handmade, self-produced mailers."

When you want to reuse past mailers, plan on repackaging them in some way. For example, take leftover postcards, trim the images to fit and paste them onto greeting card stock (see chapter 5 for this technique). This repackaging of your piece alters the client's perception and allows you to use the same image twice!

Do It Well, or Don't Do It

The biggest mistake photographers can make in their direct mail marketing is a lack of consistency and quality of design and production. *If you can't do it well, don't do it.* This does not mean spending a lot of money! It does mean coming up with a good design concept. As soon as you have the concept, find out how much the entire campaign will cost and start setting that money aside. Plan a budget for your mailings by getting design, production, and printing estimates before you need to spend the money.

In conclusion, Morgan Shorey sums it up nicely: "To make sure your prospective clients know you are special, simply be consistent and make sure they see credible work coming from your studio. Also, the regularity of the mailing lends to your credibility."

Figure 4-7

CAll Me At 673-0594

Photo by Shawn Michienzi, Ripsaw, Inc. © 1999 Ripsaw, Inc.

(This issue)
Ripsaw, inc. 1625 Hennepin ave. so. minneapolis minnesota 55403 Tel. 612-673-0594 FX 612-673-0531 photographers: SHaWN MiCHiENZi, JoE PACZKOWSKi. Producers: Mitch Sondreaal, sarah Kottke digital services: D'palmz. Brad Palm 612-339-2000 scans: Weston Engraving 612-788-8308 pre-press production: rick haring 651 628 0664. print production: Karen norberg 612-928-9026. copyWriter: Luke Sullivan. art director: Warren johnson © 1998 RiPsaw, inc.

Chapter 5

PROMOTION PIECES

PROMOTIONAL MATERIALS ARE GENERATED FROM MANY SOURCES. IT IS UNLIKELY THAT you can have too many promo pieces, but you can easily end up with the problem of unrelated pieces. Write your marketing plan (see chapters 20 and 21) first, and then design your promotional material!

To start, let's look at the design of your promotion piece. Leftover direct mail or ad reprints are not your first, best choice. You need promotion pieces designed for their intended use in sales correspondence. A co-op approach, combining the talents of a creative team, has always been popular in producing promo pieces. *Warning!* Be careful when using this approach for your primary promotion piece, as this process rarely produces on any kind of deadline or schedule you can count on!

PRIMARY PROMOTION

First you'll need "primary" promotional materials. They can be done inexpensively and nicely; the key is *planning good design and production*, not just spending money. These are traditional, visual pieces used most often for sending ahead to get an appointment or for leaving behind after showing a portfolio.

Al Satterwhite of Satterwhite Productions, Inc., *www.alsatterwhite.com,* uses classic and timeless design and image-selection criteria for his primary promo piece (figure 5.1). It works for four reasons: It is designed for file size ($8\frac{1}{2}$ x 11"), it uses five color images, it affirms his marketing message, and it includes a line of copy—"Action-Sports-Adventure"—to support Al's strong visual statement.

Figure 5-1

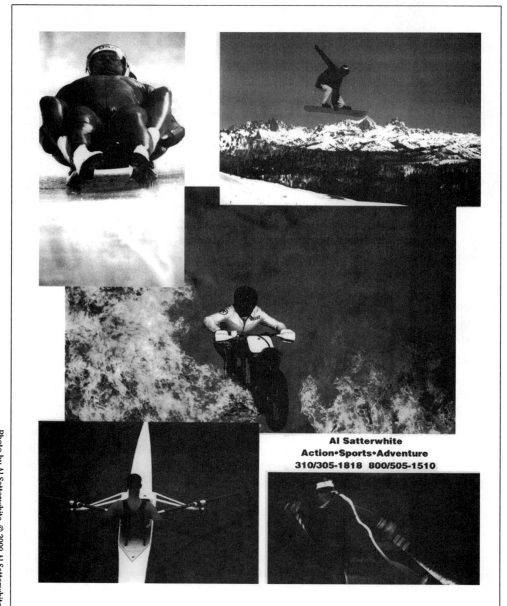

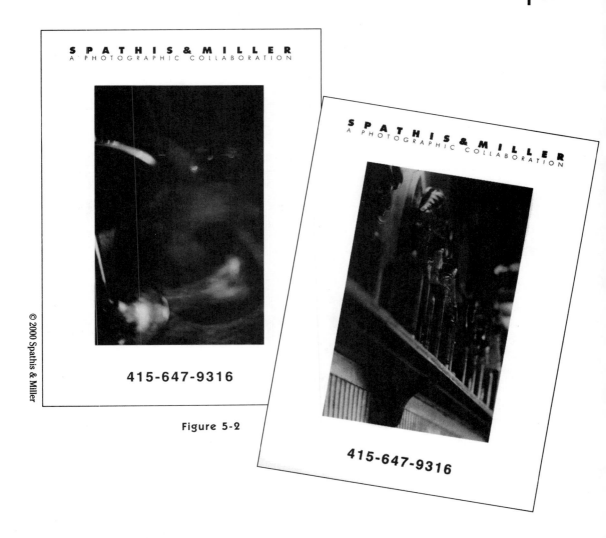

Figure 5-2

For their correspondence, **Michele Miller and Dimitri Spathis of Spathis & Miller Photography,** *www.spathismiller.com*, use a series of color, single-image cards. The front of each card (figure 5.2) uses both design and image consistency to make the point of their marketing message; the back (figure 5.3) gives their prospective clients four different "contact" options: Web site, address, phone, and fax.

Production Methods

The traditional and low-cost production method of mounting ink jet or photographic prints onto card stock works best when you have a very small target audience and quantity to produce. It is also great for those of you just starting out with more time than money, as it is a labor-intensive promo production method. If you first have the card stock printed in quantity with your name,

S P A T H I S & M I L L E R
A P H O T O G R A P H I C C O L L A B O R A T I O N

www.spathismiller.com

PH#: 415-647-9316 FAX#: 415-643-4823
801 MINNESOTA STREET SUITE 10, SAN FRANCISCO, CALIFORNIA 94107

© 2000 Spathis & Miller

Figure 5-3

phone, location, e-mail, and Web site information, then it is easy to paste on the prints in smaller quantities as needed.

For quantities of up to 100 copies, another method is inkjet printing from computer-created files. These inkjet printers are not expensive, but the hidden costs of using them for promo pieces are the learning curve, the graphics software, the page-per-minute speed, the photo-quality-paper costs, and the ink cartridge costs. To avoid a lot of investment (you will still need the learning curve to create the digital files), rent computer time at a center open to the public to allow you to create the file; the center can then print the promos from your disk.

The next step up is to take the same computer-generated file of your promo and find a company that offers Docutech output printing of your file. This works well for the volume of over 100 to 500 (even up to 1,000). Quality is better than inkjet but not quite as good as offset printing, where you have the widest range of choices in paper, inks, and other design elements.

With a larger mailing of 500 to 1,000-plus copies, you want to check the price for traditional sheet-fed offset printing pieces. Also check out offset printing without film or plates directly from your digital files, sometimes referred to digital-direct printing.

Quality Doesn't Necessarily Mean Expense

Design and quality of production are the keys no matter how you print your promotion pieces. You don't have to spend a lot of money for promotion pieces to do them well!

Ira Gostin shares his successful marketing plan for promotion pieces: "To make sure we don't use 'shotgun' or 'sniper' efforts, we spend extra time on the

GOSTIN
photography

EDITORIAL PHOTOGRAPHY

Our mission is to create outstanding, dynamic, and results-oriented photography for our clients. We pledge to provide you with photography that exceeds your needs and expectations. We are committed to quality and to professional business practices. And to creating images in an atmosphere of innovation and fun.

WHO WE ARE

Gostin Photography has earned the respect of editors nationwide for our aggressive and enthusiastic style of photography. We bring the studio to the subject, ready to conquer the photography challenges and create indelible images. We also have digital capabilities for sending images via email or modem. For more information, contact ira@gostinphoto.com, www.gostinphoto.com or call (775) 333-9173.

SELECT CLIENTS

Entrepreneur	Time	Comstock's Business
Los Angeles Times	Casino Journal	Independent Business
USA Weekend	Supply House Times	Graphic Arts Monthly
American Cowboy	USA Today	Warehousing Management
Nevada Woman	Business Start-Ups	RV Business
Nevada Magazine	Cigar Aficionado	Popular Science
Life Association News	Profiles	The New York Times

CLIENT SUCCESS STORIES

"Ira Mark Gostin's unforgettable photographs of the modern West are lasting images of a lingering legacy."
Jesse Mullins, *Editor, American Cowboy*

"Ira really captures the look that we want for *Comstock's Magazine*. He is professional and a pleasure to work with. He worries about the details so I can rest easy."
J.T. Long, *Managing Editor, Comstock's Magazine*

"An adopter of professional quality digital photography, Ira Gostin is the obvious choice for a digital shooter in the West.!"
John B. Carnett, *Photo Editor, Popular Science*

775/333-9173
316 California Avenue, Suite 96 ★ Reno, Nevada 89509-1650 USA
Fax: 775/333-9142 ★ www.gostinphoto.com ★ Email: ira@gostinphoto.com

Figure 5-4

Figure 5-5

GOSTIN
Photography

 CLIENT SUCCESS STORY

Event:
First USA Bank wanted to launch their new **VISA LAS VEGAS** branded credit card in true Las Vegas Fashion---with a bang! They contracted with **DRGM Advertising & Public Relations** to produce an exciting event to introduce the card.

Strategy:
Don Vetter, DRGM's public relations guru and I developed an event to introduce the card. Our goals were:

- Produce an event that would receive National media attention and publicize the VISA Las Vegas brand name as much as possible.
- Create a set of visually exciting photographs for media placement.

The world-famous **Flying Elvi** would sky dive into Las Vegas to introduce the card to the market. Additionally, we would photograph the Elvi in various set-ups holding the Visa Las Vegas Card and produce a variety of photographs to promote the product.

Results:

- The event was a **resounding success**. Ten **Flying Elvi parachuted in to Las Vegas carrying the credit cards** to the applause of passers-by and the media. Las Vegas showgirls were on hand to greet the media which turned out in force. We assisted in all scheduling and logistics of the event.
- In addition to the ground photos and air-to-air photos from a remote showing Elvi with the card in free-fall, we created a variety of images with the Elvi and showgirls all holding mock-ups of the Visa Las Vegas card. Photographs were sent to the Associated Press and a photo package was distributed via PR Newswire. To date, play has been fantastic and DRGM and I have a very pleased client!

775/333-9173
316 California Avenue, Suite 96 ★ Reno, Nevada 89509-1650 USA
Fax: 775/333-9142 ★ www.gostinphoto.com ★ Email: ira@gostinphoto.com

phone qualifying our leads and referrals. My most successful campaign is our short-list process, where we select a small group of clients out of the larger group we mail to and give them extra personal attention by sending in-house-designed and -produced promo materials from our inkjet printer with follow-up calls" (figures 5.4 and 5.5).

Julie Diebolt Price of JDP Photography, *www.jdpphotography.com*, uses a creative idea: "For the business logo on my promos, I use my signature as an alternate to the lighthouse photograph. My signature is distinctive and works as a graphic for a logo. I like to use my Oregon Lighthouse photo because it is a popular image, it's won some awards, it's colorful, and, as

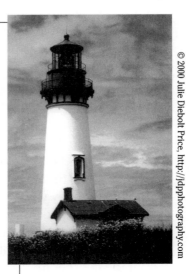

JDP Photography

www.jdpphotography.com
10381 Prather Lane
Tustin, CA 92782-1437
Phone/Fax: 714•669•4JDP (4537)
Email: jdpphoto@earthlink.net

August 22, 2000

Ms. Maria Piscopo
2973 Harbor Blvd., #229
Costa Mesa, CA 927626-3912

RE: Artwork Submission for 3rd Edition

Dear Maria,

Enclosed are the three black and white artwork pieces that I am submitting for the 3rd Edition of your book, The Photographer's Guide to Marketing and Self-Promotion.

Permission is granted for one-time publication of the enclosed images in your book with photo credit to Julie Diebolt Price © 2000.

If you need anything further, please feel free to contact me by phone or email.

Very best regards,

Julie Diebolt Price

Julie Diebolt Price

Enclosures: 1) Gondola, b&w, 7'x5" photograph
2) Yaquina Head Lighthouse, b&w, 5"x7" photograph
3) Image Magazine Promo Piece, 8.5"x11 hi res paper document

Figure 5-6

Figure 5-7

I'm an image maker, I felt I should use a photograph on my business card (figures 5.6 and 5.7).

"I have since incorporated the lighthouse image on all business communication: letterhead, invoices, statements, and labels. The Oregon Lighthouse is also on my Internet home page; I prefer electronic promotion at the moment because I'm still working on deciding what to print."

SECONDARY PROMOTION

"Secondary" promotional materials are added once you have some basic visual materials for your send-ahead and leave-behind sales correspondence. Some of these materials include Web sites, capabilities brochures, text-only or information promos, newsletters, client-printed materials, and nontraditional or "specialty" advertising items.

Web Sites

More thoroughly discussed in chapter 9, Internet marketing is the new tool. Though most often used as a portfolio or as an ad, Web sites are being used by many photographers for promotion as well, because of a Web site's speed of image delivery, flexibility, and accessibility.

Ira Gostin points out, "The Internet helps a lot to get our materials into the client's hands. For instance, I recently received a call from an art director whom I had not worked with before. She was anxious to hire a photographer right away, and I was able to direct her to my Web site while we were still on the phone, so she could see my work. Another time, I was at my desk and was able to e-mail a photo from my digital files to a prospective client while we were still chatting. The sample photo arrived and she hired me on the spot. But I look at the Internet as a sales promotion tool, not a marketing tool. Very few calls come in from the Internet first. Most of the time, the call comes in, and then I refer them to the Web site. It closes the deal for me faster. It allows me to book the job without having to ship a portfolio. I do not believe that art directors (for advertising photography assignments) are searching the Internet yet for individual photographers. They are first going to a list site like ASMP or Global Photographers, then calling the photographer or getting a direct referral to the site."

Capabilities Brochures

A capabilities piece needs to be flexible to work for each of your studio's different marketing messages (see chapter 2). Each version should include all the basics (your background, client testimonials, client list, professional memberships, equipment available, facilities inventory, map to your studio). Then you can add different inserts for different messages, such as "food photography" or "people photography." This is a good design because it is adaptable for any situation such as send-ahead or leave-behind. Note: This is not a direct mail piece but it works very well as an "offer" in a direct mail campaign. For example, in the direct mail letter, the text would read, "Call for our capabilities brochure."

It is also a multiple-purpose piece. Besides using it as a promo piece, it can be included in cost proposals to add power and impact to packaging your price (see chapter 15).

The most flexible format for a capabilities brochure is a presentation folder (customized with a logo on the front cover) and inserts printed in advance or printed as needed, depending on the client. This format is the most easily used and customized for individual client presentations. This is especially important in today's new marketplace, where you need a number of specialties to build a successful business.

Text Only

Information-filled promotional materials are great supplements to the visual materials. For example, you can design and print a studio "locator" map that can stand alone or work in a capabilities brochure.

Background information on you and your studio is important. Who you are as a person can help a client decide to hire you. These pieces can be used for both consumer (wedding/portrait) clients as well as commercial photography clients.

Another text-only piece is a page of client success stories or testimonials. One design tip: When you quote a client, use only her name and job title. When a client changes her company, your piece becomes obsolete. Avoid this problem by planning ahead.

Figure 5-8

Figure 5-9

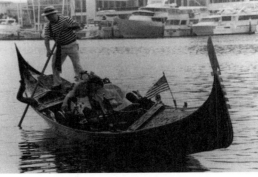

Newsletters

Newsletters are an intimidating prospect for photography promotion. Now, with in-house desktop publishing software, they are growing more popular. They are labor-intensive and time-sensitive and take a lot of commitment. You have to come up with some interesting and newsletter-worthy copy on a regular basis.

You may decide to deal with this as an Internet marketing tool (see chapter 9). Adding newsletter style "editorial content" to your Web site is one way to help motivate clients to come back and visit.

Client Projects

Your client's printed pieces (or even Web sites) using your photography will create an opportunity for promotion. Julie Diebolt Price used a client piece for her promotion (figures 5.8 and 5.9). Use the equity of the client's company name as long as you know you are going to be proud to show this piece as an example of your latest work.

Another great use of client printed projects is the "back printing" of a client's piece. For example, a client uses your photos and their copy on the front side of a sheet, leaving the blank backside for you. You simply send them back through a printer adding your own promotional copy on the back, blank side.

SPECIALTY ADVERTISING

When you have done both primary and secondary promo materials it may be time to get creative! Being creative does not mean spending a lot of money. Specialty advertising is a traditional marketing tool used in many businesses to build name recognition. You probably have several on your desk right now.

These are coffee cups, printed notepads, mouse pads, pens, pencils, felt tip markers, with promotional copy printed on them, but what can you do that's different? Again, your marketing plan will dictate your specific direction. Be creative, you may even come up with a new twist on the old coffee cup!

CONSUMER CLIENTS

For the wedding and portrait client, **David Rigg of Sandra David Fine Art, Inc.,** *www.SimplytheFinest.com*, reminds us, "Attracting the retail/consumer client means your promotional material is part of the entire marketing strategy. You must carefully plan and execute the sequence of imagery that the prospect/client will be exposed to, in order to be sure that your marketing message is clear and presented in a logical order. Less is more! Don't blow your

Figure 5-10

Figure 5-11

Figure 5-12

Figure 5-13

entire body of work on a brochure or Web site. Leave them wanting more: That is the key to creating the desire that will sustain the enthusiasm required to complete the sale. If you have worked professionally for a limited time, more than likely, your body of really great images will be limited, so use them wisely. You cannot have the same images on the walls of your gallery that you have in the brochure or on the Web, or you may give the impression that you have not been in the image-making business very long, which cuts right to the core issue of credibility. Make sure the process works for you and not against you."

DIGITAL CLIENTS

For his digital clients, Philadelphia-based advertising photographer Michael Furman and his reps use these promo pieces primarily for sales correspondence. While an experienced studio and location photographer can shoot anything, Michael's promos illustrate his "automotive photography" marketing message for the national consumer ad campaign clientele he markets to (figures 5.10, 5.11 and 5.12).

PHOTO SPECIALTIES

For his niche market doing portraits of pets and people, David Sutton, www.suttonstudios.com, of Chicago-area Sutton Studios, designed larger than life business cards. The $2\frac{3}{4}$ x $4\frac{3}{4}$" business cards make excellent promotion pieces for one of his many marketing messages, "Dogs and Dog People" (figure 5-13 shows four of the cards in his series).

The nice thing about this idea for a promotional piece is that it can be used as a template, and different copy and images can be dropped into the same layout.

LOGO DESIGN

Finally, not only will a professional logo provide you with the required tools for business correspondence (letterhead, envelope, and business card), but it will carry over into use on your promotional pieces. **Zave Smith of Zave Smith Photography,** *www.zavesmith.com*, did a complete makeover for his photography business, starting with his correspondence (figure 5.14) and then using the logo and design theme on his unusual 6-inch circular printed promos (figure 5.15).

Photo © Zave Smith, Design by Todd Weinberger

Figure 5-14

Figure 5-15

Photo © Zave Smith, Design by Todd Weinberger

Chapter 6

PUBLIC
RELATIONS

GETTING PUBLICITY IS ONE OF THE BEST AND LEAST EXPENSIVE FORMS OF SELF-promotion for photographers. It is underutilized simply because most photographers are hesitant to talk about how "great" they are. But—think about it—if you are not shouting your name from the rooftops, who will be? Besides, where do you think the media gets the news? After covering natural disasters and tragic accidents, reporters come up with story ideas from news (press) releases that businesses like yours are sending in to them! So put your feelings aside and, with a little planning and research, you can easily add publicity to your self-promotion plan.

Simply defined, public relations is getting all types of people to discover you (through the print and electronic media) and remember you. In today's competitive marketplace, being recognized can give you a cost-effective and important competitive edge.

Publicity also gives you the one thing you can't buy with any advertising or direct mail campaign. It gives you credibility. Because you must submit your story and be accepted to be published, this gives you the credibility and an

aura of being "chosen" for success. It works to strengthen and support your advertising, direct mail, and selling efforts. Another major benefit is the additional promotional material you can create from reprints of any publicity. You can use these reprints for mailings or cost proposals to supplement the promotional materials you design and produce.

First, let's dispel a myth. You don't get publicity just because you are considered a great photographer. You get publicity because you submit to be considered!

There are three parts to planning publicity for your photography business:

1. Planning and writing press releases
2. Entering and winning awards
3. Planning events and promotions

PLANNING AND WRITING PRESS RELEASES

The most common tool of public relations is the press release. The press release is a standardized form of communicating some "newsworthy" item to the editors of publications. Upon evaluating your press release, the editor then decides whether or not to publish your story. There are no guarantees you will be published, and the protocol of publicity does not allow you to call and ask to be published. Publicity is a form of a third-party endorsement, which promotes credibility.

It is simple to write and submit press releases. You start with a media list (a list of both print and online publications) that is up-to-date with the name of the editor who reviews press releases. It is a good idea to call first and ask for the name of a specific editor who deals with business press releases like yours. Be sure to submit your releases to magazines, newspapers, and newsletters read by your clients, your community, and your peers.

An example of client media would be a trade publication. Community media would include your local newspaper, while your peer media would be photography publications.

Client publications are an obvious choice for submitting your press releases. You want to publicize yourself to people who buy your photography. But that is not the only publicity you seek. Everyone reads the local paper and, because the goal of public relations is repeated exposure of your name and firm, some of this more "general" exposure does influence clients. If you are not sending your press releases to community and photography publications, you're missing out on the chance for referrals and some great reprints! All this costs you is the time to write the release and the postage to mail it. You don't pay for the publication of your release.

Here are some examples of "newsworthy" items that could generate a press release to all of the above media.

Newsworthy Events for Press Releases

- You relocate or open your studio
- You add personnel to your staff
- You celebrate the anniversary of your firm
- You give a workshop or write a book
- You win any kind of award
- You expand your roster of services
- You participate in a pro-bono community service project
- You are elected to an association's board of directors
- You install new equipment or upgrade studio facilities
- You successfully complete a project with a client

The news must truly be of interest and value to the readers of the publication. Blatant self-promotion that just advertises your work will not be accepted and reduces your credibility with the editor. However, the more you submit, the more likely it is that you will get published. So get busy and start planning ideas based on the above list.

When the editors get to know what you do as a photographer, they will call on you when they have their own story ideas and need an interview or a quote. Remember: You have no control over the media, which, of course, increases the value and credibility of their stories when they choose to run one about you.

The press release format is specifically designed to be read quickly and to give the editor an immediate sense of your news. Include all the facts (who, what, when, where, why, and how) in the first few sentences without flowery descriptions or adjectives. Double spacing is *required* and allows the editor to work right on the release, adding comments or editing. The date and the phone number at the top are required information and the ### at the end indicates that there are no more pages. Always write in the third person and don't forget to enclose a photograph that illustrates your news. Send your press releases by e-mail only when the publication solicits your news in this format (check its Web site first).

Here are sample press releases. Follow the format below except when you print your releases, *be sure to double space* first and don't forget to include visuals or photos whenever possible.

Sample "Gave a lecture" release

FOR IMMEDIATE RELEASE For information:

(Today's date) (Add name, phone number, and e-mail address)

**MANAGING CREATIVE SERVICES CLASS SCHEDULED
FOR FALL SEMESTER**

PEORIA, IL-Designers, graphic artists, creative services managers, art department managers, computer artists, and other creative professionals will learn how to increase their profitability and productivity with Dynamic Graphics Educational Foundation's two-day class, "Managing Creative Services." Instructor Maria Piscopo will teach the class in Chicago on September 14 and 15, in Orlando, FL on October 5 and 6 and in Hartford, CT on November 30 and December 1.

Piscopo will teach productivity, time/stress management, how to motivate, communicate and delegate to a creative staff, copyright, and other legal aspects of working with freelance creative professionals. In addition, attendees will learn how to avoid "panic" project management, develop interviewing and hiring guidelines, enhance the image and prestige of the creative department and achieve their personal career goals.

Call for free catalog and registration information, (800) 255-8800, or visit Dynamic Graphic's Web site, http://www.dgusa.com. For Piscopo's one-day workshop, "Making Money as a Freelancer," or any corporate in-house training, contact programs director at (800) 227-7048.

Piscopo is a member of Society of Photographer & Artist's Reps and teaches at The Art Center College of Design. She has been published in HOW Magazine, Rangefinder, Shutterbug, I.D. Magazine, STEP-BY-STEP Graphics and Communication Arts and can be reached at http://www.MPiscopo.com. Piscopo is the author of the Photographer's Guide to Marketing & Self-Promotion, published by Allworth Press, and Marketing & Promoting Your Work, published by NorthLight Books. Turner Video of Newport Beach, CA produced her series of four marketing videos. Piscopo can be reached on the Web at www.mpiscopo.com.

###

Figure 6-1

Photo by Stan Sholik, © Stan Sholik

Sample "Interesting project"
press release

FOR IMMEDIATE RELEASE For information:

(Today's date) (Add name, phone number, and e-mail address)

DIGITAL IMAGING PUTS POPCORN COMPANY INTO THE SPACE AGE

SANTA ANA, CA-Stan Sholik, owner of Stan Sholik Photography, www.stansholik.com, has recently completed an unexpected assignment for a digital image for the cover of Cal Corn's Popcorn Emporium annual catalog. A starfield background and simulated planet earth were generated entirely by computer. They were then combined and the planet shaded to match an original transparency of the popcorn kernels. Motion streaks were easily added and the image output as a 4 x 5" transparency for reproduction.

The original assignment called for still life studio shots of the popcorn products and packaging. When Cal Corn president Bill Sanderson saw Stan's photo-composites on display in the studio, he said, "I inquired about doing a 'space age' shot following up on the current interest in the twenty-fifth anniversary of man's moon landing and the activity on product the planet Jupiter. Stan's image of our popcorn kernels flying through space over the earth not only replaced our traditional cover photo, but became a fabulous marketing theme, 'Popping the world-one kernel at a time.' It reflects both our unique custom manufacturing process and our desire to stand out among the competition."

Stan Sholik specializes in combining product photography with digital imaging and is based in Santa Ana.

\#\#\#

Sample "Wrote a Book" press release

FOR IMMEDIATE RELEASE For information:

(Today's date) (Add name, phone number, and e-mail address)

LEARN TO CREATE OUTSTANDING PHOTOGRAPHS OF MINIATURE SUBJECTS

SANTA ANA, CA-Part of the continuing wonder of photography is in its ability to let us to see the world in new ways. Nowhere is this more the case than in the world of close-up and macro photography. A new guide to exploring this world is provided by StanSholik and Ron Eggers in their book *Macro and Close-up Photography Handbook*, published by Amherst Media (*http://www.AmherstMedia.com*) of Buffalo, NY.

This book explores close-up and macro photography with 35mm single lens reflex equipment. The first section covers the equipment required and the techniques used in close-up and macro work. The second details how to apply the equipment and techniques in the field. The emphasis is on working in the lower-magnification range using lightweight and easy-to-use 35mm camera equipment and accessories that can yield high-quality images.

The third section addresses the equipment required and techniques employed for studio close-up and macro work. Because the studio environment lends itself to a very methodical approach, where ultimate image quality is the overriding consideration, this section deals with higher magnifications and more complex 35mm equipment and setups. There's less of an emphasis on automation and more on calculation to obtain desired magnification requirements, lighting setups and exposure values.

Macro and Close-up Photography Handbook provides advanced amateur and professional photographers with clear, easily understood information on:

- Photographing flowers, jewelry, crystals, insects and more
- Selecting equipment
- Lighting techniques
- Filters
- Metering
- Camera support systems

Stan Sholik has spent over two decades as a commercial and advertising illustrative photographer in Orange County. Early in his career, he began specializing in close-up/macro photography, motion-simulation and in-camera photo composition to enhance the images created with his large-format cameras. He has also gained a reputation as a writer on both conventional and digital imaging topics, with articles in *View Camera Magazine, Camera Arts, Photo Lab Management, Petersen's Photographic* and *PhotoPro*. Self-taught as a photographer, he holds a BS degree in Physics and an MA in English from Carnegie Mellon University in Pittsburgh.

Ron Eggers is the Senior Editor of NewsWatch Feature Service and a contributing editor of Photo Lab Management Magazine. His writing covers computer applications, technology, photography, electronic imaging, and visual communications for numerous magazines including *Petersen's Photographic* and *Photo-Electronic Imaging* in the photographic field.

Macro and Close-up Photography Handbook is available at better bookstores and from Amazon.com.

###

Figure 6-2

Photo by Stan Sholik, © Stan Sholik

Sample "Expansion of Services" release

Sutton Studios is owned and operated by David and Lynntia Sutton. David Sutton, a Chicago-area photographer, has developed both a consumer portrait and commercial photography business with his intimate and touching images of pets, and people with their pets. As you can see from his press releases (figure 6.3) and photos (figure 6.4 and 6.4A), his approach is impressive and attention-getting. The resulting articles have appeared in such diverse publications as the *Picture Professional, Pet Life Magazine,* the *Chicago Sun-Times*, the *Chicago Tribune* and *Chicago Magazine*. These press releases have also resulted in both national network and local cable television appearances.

###

Bottom line, getting published is like rolling a boulder downhill. Once you start, the publicity takes on a momentum of its own. Identify what you love to do, locate all the media channels available and start mailing those press releases.

ENTERING CONTESTS AND WINNING AWARDS

Publicity automatically comes from winning any type of juried or juried exhibition or publication of your work, but then it gives you a wonderful opportunity to write a press release of your own. But it is very important to realize

Figure 6-3

FOR IMMEDIATE RELEASE

CONTACT: DAVID OR LYNNTIA SUTTON 847-328-0346
SUTTON PHOTOGRAPHY STUDIOS
EVANSTON, IL 60202

DATE: MAY 2 - JUNE 11, 2000

Sutton Studios

1532 Crain
Evanston, Illinois 60202

tel 847.328.0346
fax 847.328.0356

"Who Loves Ya!"
Photography Exhibit
At Café Selmarie, Chicago (Lincoln Square)

"Who Loves Ya!", a new exhibition of black and white photographs of pets
and people with their pets by Evanston photographer **David Sutton** will be on
display at **Café Selmarie**, 4729 N. Lincoln, in Chicago, beginning May 2nd and
continuing through June 11 of 2000.

These touching, offbeat and often funny photos showcase the loving bond
between pets and the men, women and children who live with them.

David Sutton has gained an international reputation for his commission
portraiture. When he's not making dogs smile for private clients, he
photographs humans and animals alike for ad agencies, corporations, design
firms, magazines & the entertainment industries.

Sutton Photography Studios
1532 Crain St.
Evanston, IL 60202
847-328-0346
www.suttonstudios.com

that you don't have to win to benefit from the entry you've submitted. Great
advantage can be gained because, in many award programs, the jurors are the
editors and clients you are trying to reach with your press releases and pro-
motions! Like press releases, the more you submit, the greater the chance of
winning and generating recognition. In addition, be sure to submit your work
to publishers of photo annuals and "best of" books. Submitting is the key to
public relations!

The award-winning work can be designed into a promo piece by itself. For
maximum benefit, the announcement of your award or exhibit should be incor-
porated into your next promotional piece, direct mail campaign, or advertise-

Figure 6-4

Photo by David B. Sutton/Sutton Studios, © 2000 David B. Sutton

Figure 6-4a

Photo by David B. Sutton/Sutton Studios, © 2000 David B. Sutton

Figure 6-5

ment. **Henry Lehn of Aspect Ratio Design,** *www.lehnphoto.com*, won a top national photo prize. Henry says, "For my work, (figure 6.5) I won the grand prize of $10,000 and publication of my photos (figure 6.6) in the Puerto Rico 2000 Photo Contest, sponsored by *Popular Photography* magazine."

PLANNING EVENTS AND PROMOTIONS

Finally, you can publicize, build name recognition and help clients get to know you by "nonselling" promotions. Here are some ideas you can use to promote your photography:

- Participating in professional associations is the perfect opportunity to come into contact with your clients when you're not selling to them. It is always easier to do this when you have an official responsibility. For example, as Program Chairperson of your local photography association, you get to call on clients as potential speakers for your association. Or, as Publicity Chairperson for an association your clients belong to, you get to meet and greet the local media.

- Working on community service projects brings you in contact with influential community leaders who do a lot of public service. The

Figure 6-6

work itself is a great way to get printed pieces for your portfolio and promotions (see chapter 7).

■ Writing articles for any media gives you the initial benefit of the exposure from publication, and reprints of the articles can be used as promo pieces.

■ Speaking at association seminars is a great way to meet potential clients and gives you the chance to write a press release. If you're new to this kind of promotion, start out with presentations on a panel of speakers—less pressure on you!

■ Hosting client association seminars at your studio is especially beneficial to the studio photographer. The theory is that if a client found his way there once, he can do it to again to give you a job the next time.

Figure 6-7

Figure 6-8

FOR IMMEDIATE RELEASE

TO TRAVEL, PHOTO AND LIFESTYLE EDITORS

SUMMER, 2000

IMAGES OF IRELAND PHOTO TOUR - SEPTEMBER 9-19, 2000

Join us in western Ireland for an opportunity to expand your personal vision, make new friends and experience a very special place through new eyes, with the guidance of an experienced teacher.

Ireland offers an unspoiled beauty that is waiting to be discovered! The pace of life is relaxing, the Irish are friendly and courteous and photo opportunities abound at every turn of the road. Our small group will travel by private vehicle through the wild and beautiful western countryside. In Counties Clare, Galway and Mayo, we'll be exploring the local culture, sights and sounds of Ireland through 'unscheduled' stops and detours revealing ancient ruins, majestic sites and seaside villages.

The Burren, in County Clare, is a wild and hauntingly beautiful region. (The word 'burren' means 'rocky place'.) It presents a vast lunar-like landscape of smooth limestone rocks, which appear bleak, yet are far from barren. Also in the area are the spectacular Cliffs of Moher, where towering cliffs rise above the powerful Atlantic Ocean. Weather permitting, we will be able to capture one of the most beautiful sunsets in western Ireland.

Connemara, in County Galway, has long been regarded as the real emerald of Ireland. The beauty of Connemara lies in the vast open areas of bog and wilderness, two dominating mountain ranges, stone walls, and scattered villages with whitewashed cottages. The natural terrain and unspoiled land offer the visitor a wonderland of sights, experiences, adventure and activities. You'll know you are in Connemara because of the light, which constantly changes the mood and tone of the landscape.

With the Atlantic Ocean making deep inroads into its coastline on the west and north, the sea has been the main influence in shaping the beauty of County Mayo. Expansive views lead the eye across bays and headlands to the boldly pronounced mountains that border the region to the south. In sunshine, the sweeping horizons are specked with highlights of delicate color; on misty days the light can seem most surreal. From the holy mountain of Croagh Patrick to Achill Island, the largest island off the Irish coast, County Mayo serves up a plethora of visual and cultural opportunities.

Land price: $2200 per person, double occupancy

Includes: Photographic instruction, entrance fees, 9 nights first-class accommodations, daily breakfasts, a Medieval dinner, land transportation and local taxes.

 Karen Schulman is available for interview. Photos available.

**Contact: Karen Schulman at (970) 879-2244 or by e-mail: focus22@excite.com
or April Darrow, Media Relations at aprildarrow@hotmail.com
www.focusadventures.com**

####

■ Sponsoring an art exhibit or community event at your studio is a nice option. It puts less pressure on you and may even be an attractive invitation for your clients to visit your studio space.

It is important to remember that you are not selling anything when you are doing publicity efforts. You are simply increasing the exposure of your name and your photography to your clients, increasing their awareness of your services and their recognition of your work.

Start today to incorporate public relations in your self-promotion plan. Review the above ideas and add to your marketing plan. Get a file and start an "ideas" public relations file from articles printed or online in an e-zine every time you find photographers written up in the media. This will give you an idea of how stories are written. Schedule a quarterly press release. You'll be more likely to come up with something newsworthy if it is on a schedule than if you just wait until something happens.

PHOTOGRAPHY WORKSHOPS

The business of photography workshops is huge and a wonderful source for press releases and getting published. It has other benefits as well. Teaching photography workshops gives photographers access to people and places so they can create unique images, provide an additional income source and press releases (figures 6.7 and 6.8). It also lets photographers follow their passion! **Karen Gordon Schulman of Focus Adventures,** *www.focusadventures.com*, took publicity to its highest level. With her husband Joel, Karen runs Focus Adventures out of Steamboat Springs, Colorado.

Here is Karen's story: "I guess I started out not really having much strategy. I began 'seriously' in photography in the early eighties, when I lived in Los Angeles. Almost from the beginning, I knew that I wanted to share my love of photography with others, and because I have a degree in education, it was a natural way to go. I offered classes in 'The Art of Seeing' (figures 6.9 and 6.10) and 'Hand Coloring Black and White Photographs' (figures 6.11 and 6.12). We did some field trips to Catalina Island and Joshua Tree National Monument, to name a few. Simple flyers, word-of-mouth, and contented workshop participants helped to build the foundation.

"I continued to do my 'personal' fine art photography and commercial work along with the teaching. Around 1985, I named the workshop business Focus Adventures. Not just the 'focus' as it relates to the camera, but as it relates to life. Using the camera and photography as a tool for self-discovery and personal growth is really what Focus Adventures is about.

"In 1991 my husband, Joel, and I moved to Steamboat Springs, Colorado, a spectacularly beautiful place. It seemed only natural to work on developing the photo workshop part of my business, concentrate more on my art work and

Figure 6-9

Photo by Karen G. Schulman,
© Karen G. Schulman/Focus

Figure 6-10

FOR IMMEDIATE RELEASE

TO TRAVEL, PHOTO AND LIFESTYLE EDITORS

SUMMER, 2000

**EXCITING PHOTO WORKSHOPS OFFERED IN COLORADO
BY FOCUS ADVENTURES**

**Steamboat in the Summertime:
Photography and the Creative Spirit - July 22-27, 2000**

Steamboat Springs, a world-class resort located in northwest Colorado, is full of western hospitality and blessed with breathtaking scenery year-round. Surrounded by majestic mountains, its beauty includes ranchlands, colorful meadows, natural hot springs, aspens and evergreens, wildlife and wildflowers. In the summertime, the excitement of the rodeo abounds every weekend. Steamboat is truly a photographer's delight!

This workshop will explore personal photographic vision and be a journey of inspiration and self-discovery. Through specific visual exercises and daily field trips, each participant will get in touch with their emotions and spirit while breaking creative boundaries and improving technical skills. Each day, the group will utilize early and late light as we photograph at various locations in the Steamboat area, including private ranches, the rodeo and pristine backcountry lakes with fields of wildflowers. We will review and evaluate our images during class sessions and gain a new understanding of our world through the camera lens. Whether an experienced photographer or enthusiastic beginner, this workshop will help participants use the camera as a tool for expanding creativity and enhancing personal growth!

Workshop fee: $595 (lodging, film and processing additional)

**ROCKY MOUNTAIN VISIONS:
SUMMIT COUNTY, COLORADO - AUGUST 3-6, 2000**

Join us in the Rocky Mountains of Summit County, Colorado, a paradise for photographers. Just a one-hour drive from Denver, Summit County combines western charm with vast scenic beauty. Focus Adventures is offering this workshop for those who are tired of the "shoot and pray" technique and are seeking to enhance their creativity while improving photographic skills.

During our 4-day workshop, we will have the opportunity to capture the elegance and grandeur of the 14,000 ft. peaks, awesome wildflowers, high mountain waterfalls and picturesque Lake Dillon and its many sailboats. The backcountry is dotted with remains of old gold mines and abandoned cabins. We may see Rocky Mountain Sheep and Mountain Goats while we photograph ancient, gnarled Bristlecone Pines on Mount Evans. From windows to wildflowers, each day will offer exciting photo opportunities as we take advantage of early and late light during our field trips.

Daily film processing (E-6 only) and critique sessions will aid in sharpening technical skills, expanding creativity and exploring personal views of the world.

Workshop fee: $450 (lodging, film and processing additional)

HANDCOLORING BLACK & WHITE PHOTOGRAPHS -
ONE AND TWO-DAY WORKSHOPS IN STEAMBOAT SPRINGS, COLORADO
One-day: June 3, 2000
Two-day: August 19 & 20, 2000

For anyone who has ever wanted to learn the art of handcoloring black and white photographs, now is the time! Whether for one's own enjoyment, commercial work, or gifts for friends and family, handcoloring is an exciting way to personalize photographs.

Also known as handtinting or handpainting, artists have been using this technique since the beginnings of photography. Originally used as a practical way to add color to monochrome images, handcoloring has grown to serve as a creative art form for many artists who wish to add originality and surrealism to their photographic work.

During the workshop, participants will learn to handcolor photographic images using Marshall's Photo Oils and colored pencils. Other coloring mediums will also be made available. No prior painting experience is necessary and painting materials will be provided. Explanation of paper surfaces, finishing techniques and film types suitable for use with handcoloring will be covered. Examples of images from different periods and artistic styles will be presented.

A photo field trip will be included in the two-day workshop. Karen Schulman has been handcoloring photographs for 20 years and has taught numerous workshops for the Marshall Oils Company. She will assist participants in gaining the creative confidence to be successful with this medium.

Karen's work is featured in the book, The Marshall's Handcoloring Guide & Gallery, by Grace & George Schaub. Her handcolored photographs appear in numerous publications, national ad campaigns and television programs, and her fine art images are widely collected.

Workshop fee: $150 for one-day class

$250 for two-day program

Note to Editors: Karen Schulman is available for interview. Photos available.

Contact: Karen Schulman at (970) 879-2244 or by e-mail: focus22@excite.com or April Darrow, Media Relations at aprildarrow@hotmail.com.

www.focusadventures.com

####

Figure 6-11

Photo by Karen G. Schulman,
© Karen G. Schulman/Focus

Figure 6-12

Handcoloring Black & White Photographs -
One and two-day workshops in Steamboat Springs, Colorado
One-day: June 3, 2000
Two-day: August 19 & 20, 2000

For anyone who has ever wanted to learn the art of handcoloring black and white photographs, now is the time! Whether for one's own enjoyment, commercial work, or gifts for friends and family, handcoloring is an exciting way to personalize photographs.

Also known as handtinting or handpainting, artists have been using this technique since the beginnings of photography. Originally used as a practical way to add color to monochrome images, handcoloring has grown to serve as a creative art form for many artists who wish to add originality and surrealism to their photographic work.

During the workshop, participants will learn to handcolor photographic images using Marshall's Photo Oils and colored pencils. Other coloring mediums will also be made available. No prior painting experience is necessary and painting materials will be provided. Explanation of paper surfaces, finishing techniques and film types suitable for use with handcoloring will be covered. Examples of images from different periods and artistic styles will be presented.

A photo field trip will be included in the two-day workshop. Karen Schulman has been handcoloring photographs for 20 years and has taught numerous workshops for the Marshall Oils Company. She will assist participants in gaining the creative confidence to be successful with this medium.

Karen's work is featured in the book, The Marshall's Handcoloring Guide & Gallery, by Grace & George Schaub. Her handcolored photographs appear in numerous publications, national ad campaigns and television programs, and her fine art images are widely collected.

Workshop fee: $150 for one-day class
 $250 for two-day program

Contact: Karen Schulman at (970) 879-2244 or by e-mail: focus22@excite.com
or April Darrow, Media Relations at aprildarrow@hotmail.com. www.focusadventures.com
####

Figure 6-13

FOR IMMEDIATE RELEASE

TO TRAVEL, PHOTO AND LIFESTYLE EDITORS

SUMMER, 2000

EXCITING PHOTO WORKSHOPS

OFFERED IN COLORADO BY FOCUS ADVENTURES

Steamboat in the Summertime:

Photography and the Creative Spirit - July 22-27, 2000

Steamboat Springs, a world-class resort located in northwest Colorado, is full of western hospitality and blessed with breathtaking scenery year-round. Surrounded by majestic mountains, its beauty includes ranchlands, colorful meadows, natural hot springs, aspens and evergreens, wildlife and wildflowers. In the summertime, the excitement of the rodeo abounds every weekend. Steamboat is truly a photographer's delight!

This workshop will explore personal photographic vision and be a journey of inspiration and self-discovery. Through specific visual exercises and daily field trips, each participant will get in touch with their emotions and spirit while breaking creative boundaries and improving technical skills. Each day, the group will utilize early and late light as we photograph at various locations in the Steamboat area, including private ranches, the rodeo and pristine backcountry lakes with fields of wildflowers. We will review and evaluate our images during class sessions and gain a new understanding of our world through the camera lens. Whether an experienced photographer or enthusiastic beginner, this workshop will help participants use the camera as a tool for expanding creativity and enhancing personal growth!

Workshop fee: $595 (lodging, film and processing additional)

Rocky Mountain Visions:

Summit County, Colorado - August 3-6, 2000

Join us in the Rocky Mountains of Summit County, Colorado, a paradise for photographers. Just a one-hour drive from Denver, Summit County combines western charm with vast scenic beauty. Focus Adventures is offering this workshop for those who are tired of the "shoot and pray" technique and are seeking to enhance their creativity while improving photographic skills.

During our 4-day workshop, we will have the opportunity to capture the elegance and grandeur of the 14,000 ft. peaks, awesome wildflowers, high mountain waterfalls and picturesque Lake Dillon and its many sailboats. The backcountry is dotted with remains of old gold mines and abandoned cabins. We may see Rocky Mountain Sheep and Mountain Goats while we photograph ancient, gnarled Bristlecone Pines on Mount Evans. From windows to wildflowers, each day will offer exciting photo opportunities as we take advantage of early and late light during our field trips.

Daily film processing (E-6 only) and critique sessions will aid in sharpening technical skills, expanding creativity and exploring personal views of the world.

Workshop fee: $450 (lodging, film and processing additional)

(more)

© Joni Potekhen

Figure 6-14

The various workshops and photo tours are unconventional experiences that combine photo instruction with travel, to encourage students to focus on understanding themselves first and the technical aspects of their equipment second. In the process of photographing the world around them, Schulman believes that participants gain more than just pretty pictures.

"I try to encourage each person to give themselves the permission to make mistakes, the permission to create," Karen says. "The more we learn to 'see' with our mind, heart and spirit, the more of an adventure life becomes."

Focus Adventures' upcoming photography workshops are based in Steamboat Springs and Summit County, Colorado, as well as in Latin America and Europe. The 2000/2001 workshop and photo tour schedule currently includes: Two Hand Coloring Black and White Photographs workshops (June 3, 2000 and August 19-20, 2000); Rocky Mountain Visions in Summit County, Colorado (August 3-6, 2000); Steamboat in the Summertime: Photography and the Creative Spirit (July 22-27, 2000); Images of Ireland Photo Tour (September 9-19, 2000); and the Cozumel Women's Photo Workshop and Winter Escape (February 4-11, 2001). Class sizes are limited and fill quickly.

Karen is pleased that the workshops have successfully remained small and personal. Eventually, more international and statewide travel will be offered. "I'd like to take more people to interesting places; not just pretty places to photograph, but places with exotic cultures, Indian ruins, music and local color that we can integrate into the program," she says.

Interested in writing about photography as a tool for self-discovery? Intrigued by incorporating travel and education in search of the 'art of seeing'?

Contact April Darrow, Media Relations: aprildarrow@hotmail.com or Karen Schulman: 970-879-2244 or focus22@excite.com.

####

stock photography, and leave much of the commercial work to the numerous photographers in town here who seemed to want to do it.

"In 1993, we published a photo book called *Steamboat Visions: A Photographic View of the Yampa Valley*, with another photographer. We self-published and printed 10,500 beautiful photo books. Presently, we have about 300 copies left, so it has been a successful project. It was the first-ever photo book to be done on this area of Colorado. Though under a different business name, Icon Press, Inc., it has served us as a portfolio of sorts, and helped us to gain name recognition. So, with the book, plus local advertising, flyers, direct mail to past workshop participants and photo clients, collectors, stock photo people, and just plain networking—all are helping Focus Adventures to grow.

"Now, with the Internet, our own Web site, and links to workshop listing sites, the name Focus Adventures is becoming better known. Whereas a few

Figure 6-15

Photo by Karen G. Schulman,
© Karen G. Schulman/Focus

years ago, more of the participants in my workshops were from around Colorado and California, now they are from around the country, if not other countries.

"I have been writing a quarterly photo column for *Marco Polo Magazine* for $2\frac{1}{2}$ years. I'm sure that helps as well. Everything supports everything else. People see the name on the Web site, maybe come to Steamboat for a ski trip in the winter and pick up the book, perhaps read my photo articles and as 'Focus Adventures' and 'Karen Schulman' become names that are better known, the workshop business grows. My annual photo workshop, 'Steamboat in the Summertime,' is full and begins this summer (figures 6.13 and 6.14).

The kit included a cover letter, company description and background, bio info, workshop and photo tour descriptions; all on paper as well as on CD.

"This spring, for the first time, I hired a professional to work with me on a public relations mailing campaign. We sent about a hundred media kits to travel and photo editors at targeted magazines and newspapers around the country. We included magazines on our list that emphasized health and healing, because I feel so strongly that using our whole selves and the camera as a means of personal growth would be an interesting topic for them. The kit included a cover letter, company description and background, bio info, workshop and photo tour descriptions; all on paper as well as on CD. A few photos were included on the CD to illustrate the workshops (figure 6.15) and the type of photography I do. A business card, a recent postcard from a mailing, a package of Starbucks coffee, all in a cool purple envelope and voila! We sent out e-mails to let editors know that something cool was coming, and then followed up with e-mails afterwards."

Chapter 7

MARKETING BY ASSOCIATION

NETWORKING IS ONE OF THE MOST IMPORTANT SKILLS OF THE SUCCESSFUL PHOTOG-rapher. Even though many photographers get behind a camera to avoid the "business" side, business is done when you get out in front! The best way to get to know prospective clients (and have them get to know you) is working the networks.

There are three types of associations to identify and interact with: client, community, and peer. Networking within these three types of associations does not involve a hard sell. It is simply the connections and relationships that you develop on a personal level. These fall outside the nonpersonal and more direct tactics like portfolio presentations, mailings, and advertising. For maximum effectiveness, the best marketing plan includes layers of these direct marketing efforts with the softer sell of networking.

In addition to being more effective, you'll also increase your marketing equity. Building equity means that, with the support of association marketing, the value of your promotion efforts will be worth more than what you paid for them.

First, your best reference for identifying different client associations is the *EA Directory or Encyclopedia of Associations*, available in the Business

Reference Section of your local library. Second, your local Chamber of Commerce—or the Web site for your city— readily identifies community associations. Third, look to sourcebooks, such as *The Workbook* and photography Web sites to identify peer photography associations.

Here is a partial list of some of the online information about photography organizations current today. Many include directories where members can buy space or get a free listing.

www.apanational.org, Advertising Photographers of America

www.asmp.org, American Society of Media Photographers

www.nppa.org, National Press Photographers Association

www.ppa-world.org, Professional Photographers of America

www.wppi-online.com, Wedding & Portrait Photographers

www.aspp.com, American Society of Picture Professionals

For most of the benefits of networking, you must be a member of the association. Association dues are not only tax deductible, they should be considered as essential a business expense as promotional material. As you read each section below, make cross-references to your current marketing plan and analyze what items can be put to work immediately!

CLIENT ASSOCIATIONS

There are six ways to incorporate associations of your potential clients into your marketing strategy.

Newsletters

Look for client associations that produce newsletters for distribution to their membership. These can be excellent avenues for your advertising and publicity. The display ads you buy can be anything from business-card size to full page. Because the circulation is reasonably small compared to many of your other advertising opportunities, your ad rates will be low. Don't be misled by the small circulation! Even if the association newsletter has a circulation of only 300, each recipient is a targeted client for your photography. This avoids "shotgun" mailing to a 30,000 circulation in order to find 300 qualified clients! If you are concerned that the production values of these publications are not high enough due to the lower ad rates and production budgets, ask for their freestanding ad insertion rate. This will allow you to print your own ad page and have the association insert it before mailing the newsletter to its members.

Membership Directories

Look for client associations that produce directories of their members. These will provide you with a source of leads for making portfolio presentations

and pitching for work. In addition, your member listing in the directory is probably free and a great supplementary advertising tool to the perfect "captive" audience. Imagine being included as a listing in the "photography" section of your clients' association membership resource directory! You will always be on a shorter list for them to choose from than if they were looking at traditional sourcebooks or phonebooks that list all the photographers.

Association Databases

Look for associations that offer their membership list as a database on CD-ROM or online. This will save time keyboarding the names and addresses into your computer. Then you have your labels for your next direct mail campaign (chapter 4) and you can search/sort the names for your selling steps (chapter 12).

Qualified, High-Quality Clients

Another advantage of professional associations is the quality of the clients you'll find. First, companies or individuals who take the time and money to participate in their own industry association tend to be more aggressive about their marketing and promotion. In other words, they are more likely to use photography than the companies that stay "home" and keep to themselves. Second, every association has recognized business practices and ethics. Clients who have their own business ethics are more likely to recognize and honor yours!

Bread and Butter Work

Though your association client contacts may not always have the work you want to do more of, they can be very good for the "bread and butter" work every photographer needs to pay the rent.

Get Involved

Finally, look for client associations that have awards programs and active committees you can join and get involved with. For example, the Hospitality Committee is an excellent choice. There's no easier networking than being the official "greeter" at a meeting. Volunteer for committees and join the board. Work with as many different committees as you can and enter their awards programs. Ultimately, this is the best way to get the experience with a potential client you often need before you can get a job from her.

COMMUNITY ASSOCIATIONS

These groups include national associations with local chapters such as the American Cancer Society or the Make a Wish Foundation. Don't forget that charity starts at home! Check with your local humane society, programs for the

homeless or hungry in your community, and the many wonderful local groups that work with kids and seniors.

Here are two benefits to your marketing strategy that come from networking with a charity or community association.

Centers of Influence

These are people in the community that are the movers and shakers—people you are not likely to run into and have lunch with on a whim! Though they may not directly buy photography, they influence people who do. Their relationship with you is an endorsement that could be a valuable marketing asset.

Community Service Projects

This is the best way to get a photography business off the ground! It is the number-one reason photographers do association marketing. Pro-bono or public service projects often bring together some of the community's best creative people. This is usually because everyone is contributing his time, attention and energy to get a lot of creative freedom on the project. Often, it is the only way you can obtain access to the people and places you need to shoot for your portfolio self-assignments (see chapter 13).

These organizations usually have high-level production values from the contribution of a printer or paper company to the all-volunteer creative team. As a benefit, you get to use these in your portfolio. So, for your time, you get many of the benefits of a "real" job: the experience of working with potential clients, client references, testimonials, publicity, and printed pieces for your portfolio.

Seattle area photographer, **Nancy Clendaniel, Clendaniel Photography,** *www.clendanielphotography.com*, says, "I usually have total creative freedom when working with my nonprofit projects. Having viewed my portfolio, they have placed their trust in me. Occasionally, they will show me samples of what they don't want, and then leave the rest up to me. As a photojournalist, I usually incorporate my talent for capturing 'magical moments' in everyday life into any assignment I take on. I figure they wouldn't have hired me if they didn't want me to replicate the same type of documentary image into their creative concept for a poster, brochure, etc.

"Then there are the really extraordinary and personal projects. These are photos I took last Christmas on the 'Children's Christmas Missions' trip to Moldova (an independent state in Russia) with a group from the Renton, Washington, Highlands Community Church (figures 7.1 and 7.2). It was one of the most amazing experiences I have had as a photographer working with a nonprofit. The photos got some wonderful publicity for the missions' effort—and for my documentary photography work. Working for a

Figure 7-1

Photo by Nancy Clendaniel, © 2000 Nancy Clendaniel Photography

nonprofit, especially a church, can be uniquely rewarding. For anyone who is burned out on the commercial photography scene, working for nonprofits may be the answer. Their budgets aren't always so big, but their hearts are huge and the benefits are endless! The sense of purposefulness makes these assignments more than just another job."

Figure 7-2

Photo by Nancy Clendaniel, © 2000 Nancy Clendaniel Photography

There are projects in your own neighborhood to work with as a photographer. Community associations have local photography needs, such as the program "Seniors Making Art," a community service project in Washington that helps seniors to enhance their quality of life by providing opportunities for creative expression through art. Nancy Clendaniel says of her experience as an SMA instructor, "From the outset of this class, I had the

Photo by Nancy Clendaniel, © 2000 Nancy Clendaniel Photography

Figure 7-3

feeling that I would come away learning more about life from the partici-pants than they could ever hope to learn about photography from me! Eight weeks later, as the class came to an end, this feeling was proven absolutely accurate and then some. With the objective of enriching the lives of the seniors by enhancing their ability to take photographs, I opted to allow each class to be a creative interplay of information and individual needs (figures 7.3 and 7.4). It opened up an area of photography—working with seniors—that I hope to pursue."

Figure 7-4

PEER ASSOCIATIONS

Marketing yourself through a group of your photography peers is the most neglected and overlooked tool of association marketing. Membership dues, along with participating in your peer association, should be considered a necessity of business, not an option. Photographers afraid of relationships with their fellow professionals have nothing to gain and everything to lose. Here are some of these benefits. Join or renew your membership today!

Professionalism

First of all, you can't really call yourself a professional in today's marketplace without being able to prove it with those magic words, "member of." Clients are much more educated and discerning today. It is the quickest and easiest way for any consumer or commercial client to determine if you are a professional photographer. Maybe being judged by the company you keep and

your professional associations or affiliations doesn't seem fair, but it is reality. Clients simply want the value of a "pro" for their money.

Information

As a member, you will get sample forms, business guidelines, supplier discounts, insurance information and more assistance with your business from being connected than you would as the traditional nonjoiner. You can call fellow members, ask questions, and get help!

Referrals

With their online directories and e-mail lists, other members can refer assignments to you. When they can't or won't take the job, you are their "backup" and can get the job as a referral.

People Skills

Finally, peer association marketing gives you the opportunity to practice all the skills you are learning—or learned and forget how to use—that come with running a business. Many photographers do not have this opportunity in school and you certainly can't practice on your clients. When you want to learn publicity and familiarize yourself with the local and national media, join the publicity committee. When you need to overcome your reluctance to call total strangers and get them to give you work, join the membership committee. If you can sell memberships, you can sell photography! Besides, your photography association gives you a safe place to practice. You can't get fired!

Julie Diebolt Price adds, "Joining associations in your own field is important. Even more important is to be active in the group. If you only attend meetings and don't participate, you are stifling your own growth. When you join committees or sit on the board of directors, your colleagues get to know you and what you are capable of.

> **"If you only attend meetings and don't participate, you are stifling your own growth."**

"Case in point—I have been a member of Professional Photographers of Orange County for a number of years. I only became active with the organization at the beginning of 2000. Since that time, I have gotten business referrals from other members, as well as opportunities for financial and educational growth that would not have presented themselves without the exposure of participation.

"I am on the Planning Committee for Working Wardrobes, which is a nonprofit organization dedicated to helping adults in crisis reenter the work force. I have been providing photographic services for several years, and have established relationships that lead to jobs.

"I have also been fortunate to connect to an organization, Adventures at Sea, which has excellent marketing skills at work. Articles have been written that need photos to go along with them. As I started shooting images for a class assignment, the company liked my work and became a client. They have quite an Internet presence and need many images for their sites. They are very willing to link to my site and provide photo credit. They were instrumental in having a press release on me written and distributed, and are experts in gaining publicity. They have built relationships with many businesses in the area, including the Newport Harbor Convention and Visitors Bureau. I think that this 'association marketing' really works."

Chapter 8

TYPES
OF
CLIENTS

A S A REP AND A MARKETING CONSULTANT, I SEE THE UNIVERSE OF PHOTOGRAPHY clients as divided into two types. One is the commercial client. The second is the consumer client.

This distinction is based on how the photography is used. Commercial clients have a business reason for buying the use of your images. It could be a lower level of commerce; for example, to communicate with their customers. It could be a higher level of commerce, for example, to sell their products or services. Chapter 11 will walk you through the different types of commercial clients and how to find them.

A consumer client (often called the wedding and portrait market) has a strictly personal reason for hiring you. There is no commerce or profit-making use of the images. If there is, then they become a commercial client.

Stock (or even fine art photography) can be for either a consumer or commercial client! If the stock or fine art photography is for display in the home of an individual for non-commerce purposes, then it is for a consumer client. If the stock or fine art photography is for display in the office and lobby of an individual's business, then it is for a commercial client.

Also, this chapter will take a look at one of the new technology markets-"new media" clients. They can be a lucrative and highly creative addition to your marketing efforts!

Then, there is digital technology. There are two distinct markets for digitally produced images so it would not be accurate to call them "digital clients." The first type of client hires you to create illustrations—images that no longer look like photographs. (See figures 8.1 and 8.2 for "before" and "after" examples of a photographic image recreated as an illustration.) The second type of client hires you to create a photographic image. With digital technology, both of these clients are still buying the use of photos. How you get there (digital capture vs. film and then scanning for digital enhancements) is not as important to the client as what it looks like when you are done!

As an illustrator, the client hires you to create a unique, new expression-your personal style. Because what you are selling here is style and is not subject-specific, you need to expose all potential clients to your work. Like any illustrator, advertising in a creative sourcebook (print or online) is probably the best marketing tool because it exposes the greatest number of clients to your style. They can then call from your Web page or ad when they have just the right job. The most common response by this client is "Great work! I can't wait to find the perfect project to try you on."

Figure 8-1 Figure 8-2

As a photographer using digital technology, you will be hired by the second client-type to get something that still looks like a photograph. This client will expect you to create the final image, instead of the outside service they previously used to put all the pieces together. The most likely client is the client you already have! This is the client who used to tell the photographer, "Shoot this so I can go have the photograph retouched or assembled later." Now the photographer can do the image enhancement and assembly. This work is usually industry-specific so you can market these images more directly than illustrations. The best marketing tools here are direct mail campaigns and sales calls. Since your studio will do the image enhancement and assembly, this expands your services and billings on jobs to existing and new clients. You can also expand your digital billings and business by working on supplied photos.

It is important to realize that subject matter is not what determines whether a job is business- or consumer-oriented. The determining factor is how the client plans to use the photos. A digitally produced portrait can be for a consumer client (a family portrait to hang in the living room) or for a commercial client (an executive portrait for an annual report).

I will leave the rest of this chapter for the photographers to speak directly to you and tell you about some of the types of clients they work with and the markets they work in. Though commercial clients are discussed in depth in chapter 11, we will start with two new views of the commercial photography market, and then look at consumer photography and the markets for digital and stock.

NEW COMMERCIAL CLIENTS

Tony Luna and his partner Harry Liles co-founded New Media Marketplace, *www.newmediamarketplace.com*, to find and fulfill the needs of this new kind of client. Tony Luna says, "The beauty of this marketplace is that there is no end in sight for the uses of new media art. Everyone can utilize some aspect of the art form in Web design, interactive media, such as kiosks, print, film, you name it. Initially, we saw a lot of hype about the capabilities of new media; then it seemed to fade down because there seemed to be little personal real-world application to the technologies. When I approached advertising agencies about helping them with their digital endeavors, they told me they had it all under control. But, as usual, the technology was far ahead of the applications. At first, only high-tech clients were interested, such as aerospace, medical technology, and computer clients. Now, however, we are getting calls from retail manufacturers, editorial content providers, television production groups, and feature film producers. And there are little clients with big ideas about putting forth a sizable presence to build their businesses rapidly. New media seems to magnify

"The beauty of this marketplace is that there is no end in sight for the uses of new media art."

the existing ways of promoting a product or service and ultimately involves more artistic suppliers in the process."

Spencer Awes is a **Managing Partner of Vubox,** *www.vubox.com*, a California-based company that has gone to the next level up from photography. Its services include design and photography for clients. Says Spencer, "For the record, I can only say my experience is that the photography market is extremely competitive and oversupplied from a commercial standpoint. Success will favor those who can effectively specialize in targeting a subject niche or cultivate a style; then photographers must recognize that markets and styles have a life cycle to which the creative person must dynamically adapt.

"Especially important, the advent of the royalty-free stock model dictates that photographers need to keep in mind new licensing and fee structures, and possibly a new type of relationship to their work. I envision advertising photographers working together in professional agencies, such as how a legal partnership might be organized, and thus sharing the profits and the costs of studio, administration, etc. Of course, in every scenario the importance of a specific marketing plan and the discipline to exercise it are critical."

WEDDING/PORTRAIT (CONSUMER) CLIENTS

David Rigg of Sandra David Fine Art, Inc., http://*www.SandraDavid.com***,** says: "Typically, the retail photography business is broken down into two segments-portrait and wedding. In the consumers' mind we are generally lumped into one category. They assume that if you do portraits, you do weddings. However, if you market yourself as a wedding photographer, many clients will never think to call you when their first baby comes along!

"Bottom line: Portrait marketing brings portraits, weddings, and the occasional commercial assignment. Weddings will primarily bring more weddings. I don't recommend that you start out doing weddings thinking that you will transition into a portrait-based operation. It rarely happens. Even with a carefully executed marketing plan, expect some life-threatening cash flow challenges in the transition.

"If your goal is to be in the portrait business, go directly after that goal. The weddings themselves can become a trap. For each wedding you book, it will, on average take a week of your billable time to complete. You have fifty-two weeks of billable time, and will most likely have to shoot forty-plus weddings at industry averages to make your overhead and salary. That only leaves you eight weeks or less to grow your portrait business, which is in my opinion, a full-time job.

"The potential problem with portrait clients is that since the up-front investment (sitting fee) is relatively low; you can expend great time and effort

and end up without a sale (the portrait prints). We are not in business for the session fee; we need the entire sale and cannot afford to have our time and energy wasted. We generally ask for a retainer that will cover what we consider to be the minimum acceptable order, but we also have a situation of demand that exceeds the supply and are able to screen our clients a little more tightly. Until recently, studio owners of average competence have been able to make a comfortable living by targeting the middle segment of the portrait market through discount-oriented promotions. These 'loss leader' promotions generally work on the principle of thirds. One-third of the respondents will make purchases that will pay for the promotion and make up for the third that will 'ace' the promotion. The final third will make above-average purchases and provide the profit structure and become loyal, repeat clients. The Sandra David concept is to dump the two-thirds who drain our creativity and profit margins, and concentrate on the third that value what we do and are willing to invest in it."

CLIENTS FOR DIGITAL SERVICES

One of the pioneers in the business of digital technology is **J.W. Burkey,** *www.jwburkey.com.* He founded D Squared Studios, Inc., an eight-person studio out of Dallas, Texas, and now works with his wife, Cathy Burkey. Cathy has worked both as an art buyer and a stock photo editor. J.W. is an award-winning photographer, who also teaches his unique, illustrative style of combining photography with computer graphics. When asked how he developed his style of illustration, J.W. says, "We live in such a visually saturated society that the images are everywhere. We get ideas from music videos, movies, magazines, everywhere. Visual ideas are everywhere."

"We have fifty or so ideas in our sketchbooks for each one we've been able to finish. Of course, I'm not talking about copying other shots. That's pointless. But you might see something as simple as a new way someone has put colors together in a store display or in a play and that will launch you straight into a shot you'd like to do. Cathy's experience as a stock photo editor also gives her great insight into what will sell. From a business standpoint, that's critical.

"We live in such a visually saturated society that the images are everywhere. We get ideas from music videos, movies, magazines, everywhere. Visual ideas are everywhere."

"The best types of clients for this work are designers and ad agencies. Since designers are early 'adopters,' they first accepted my work. Now it's considered safe for ad agencies, so I'm doing a lot of work for them, too.

"I love editorial but I seldom get to do it due to the low rates. I have found that there are a few magazines that actually pay a decent amount, say, $1,500 for an original photo-illustration. That's a practical fee provided that it's some-

thing we can sell as stock later. Oddly, these are usually lesser known magazines. The rich magazines are the ones who want to take advantage of photographers and illustrators.

"Working on someone else's images when I don't do the original photography is no problem if that person is working with you as a partner. It's important to have some input before the image is shot. Basically, the best images seem to always start out with a strong idea. We build and improve as we go, but we start with an idea of where we want to go. Also, it's important to shoot with the computer in mind as well as with the end image in mind. The advantage and disadvantage of having a partner is kind of two sides of the same coin. Creatively, it's easier to just please yourself. But having two people helps keep you from going off on a tangent that only you will understand. If your partner stares at you and says, 'I don't get it,' then chances are the viewing public won't get it either."

Philadelphia-based advertising photographer **Michael Furman** says, "Today, digital is in every part of my business. A photographer can shoot digitally,

> **"If photographers also control imaging, they have better control over the overall project budget."**

thereby providing color separations as he shoots. From there he can do color correction, image manipulation, assembly, etc. If assembly needs to be done, the photographer can provide possible stock shots to use as backgrounds or minor elements. The photographer can control color separations, proofing, image manipulation, and long-term image storage. This can also provide photographers with better control of a client's use of image.

"If photographers also control imaging, they have better control over the overall project budget. Therefore, the photographer can plan the shoot to incorporate digital components and provide a better product to the client."

Randy Becker of Elite Photo Graphics, Inc., *www.elitephotographics.com*, says, "Even though I don't capture digitally, a lot of clients want digital so I now can claim 15 percent of my business is in digital sales. I offer a digital file as a product instead of a transparency or a print of an image. I always ask how they plan to use the image and offer digital accordingly. I also explain the different file types and help my clients choose the appropriate file type they need. My clients know I will ask them lots of questions. In order to quote a correct price to them according to the intended use, I offer a digital solution if it is needed by the client. My clients don't care if I capture digitally or conventionally (most don't know the difference); it is the image they are interested in.

"As I ask my questions, I also educate my clientele as to which types of digital files would be most appropriate to satisfy their needs. I now have some clients coming back a second time already knowing what kind of digital file they need!

"Here are some of the most common questions I get when I deal with first-time clients for digital services:

- Can you make this image ready for my Web site?
- How can we make sure it won't take an hour to show up on someone's computer screen?
- Can a printer take the digital file and simply add it to my project?
- What the heck is a GIF?
- Will I be able to view the images on my computer screen?
- Should I use the same file for my brochure after I use it for my Web site?
- I have a Mac. Are you sure I will be able to use your PC-generated file?
- Do you make copies of the file so I can get more copies later if I need them?
- Can you take out some of my wrinkles?
- Really?

CLIENTS FOR STOCK PHOTOGRAPHY

Roger Ressmeyer, Vice President of Getty Images, Inc., *www.gettyimages. com*, is a photographer, former picture agency owner, and now a business development executive at Getty Images who has the following comments about the stock photo marketplace: "1999 was a pivotal year for online image search and digital delivery. Both exploded into dominance in North America. Simultaneously, there was an accelerating consolidation of the larger and many smaller photo agencies. The mergers were triggered in part by the incredible cost of launching and continuously updating an e-commerce-enabled Web site, and the additional costs of creating digital assets for licensing on those sites. Yet another new expense was traffic building, or driving qualified buyers to the Web sites. Agencies realized that simply launching a Web site wasn't enough. Many looked to partnerships and/or mergers as a means of minimizing these overwhelming new marketing and technology costs.

"I don't personally believe that the bigger agencies will wipe out the smaller ones. There's plenty of room for niche-market and boutique stock photo agencies. This creates a variety of possibilities. A small group of highly creative photographers showcasing a new style or viewpoint can do very well in today's sales environment. Opportunities abound that rarely existed in the past, such as distributing successful brands through larger companies, or positioning a successful start-up for acquisition.

"Quality is the key. Pay attention to your own heart and vision. Find ways to maximize your own creativity. On the Web, you're up against a lot more competition than in the old marketplace of dupes, couriers, and polypropylene sleeves. Clients are increasingly discerning and educated. In this brave new world, it's harder to sell B-quality images since clients have easy and quick access to so many A-quality photographs. Avoid creating a complicated, stress-

ful business life—make that part simple so you can concentrate on the images and art that draws us all to photography.

"As an individual photographer, you will probably decide to pursue more than one channel for licensing your work. To be successful, you don't need to make a lot of sales. Hold back your best-of-the-best pictures for high-priced sales based on clearly defined, limited use. To do that, it's very important to protect your most saleable images and their similars from competing with themselves. These will do very well if you place them with stock agencies that specialize in rights-controlled e-commerce."

John Kieffer says "When I began in the stock photo business, I concentrated on the subject I love most—nature—and it's still the reason I stay with the business. Although I consider myself quite a good photographer, I feel there's only one reason I've been able to stay in business. I've been able to stay ahead of most photographers in terms of marketing."

"When I began, there were already a number of fine landscape photographers with good stock libraries. Consequently, I never had the benefit of being with a "big" stock agency, where all I had to do was shoot, submit photos, and let the checks roll in. Although I'm now with several stock agencies, I've also had to learn what sells and how to sell it. As with many things in life, this turned out to be a blessing in disguise, especially in this new age of the mega-agencies and the Internet.

"I also learned to concentrate on photographing stock shots of Colorado, so I would have a strong local advertising market to sell to. Generally, local art directors and photo buyers don't call up and ask for a specific mountain. They want one or two photos that personify Colorado, often for a company's brochure or other marketing tool. As with most advertising photography, the overall feeling should be positive and upbeat. With nature, this means nice weather: 'Blue skies still sell.' If it's fall, there must be changing Aspen trees.

"Outside Colorado, the subject matter broadens, but for most advertising uses, stock photo clients are looking for that one image that can really convey something conceptually. I love photographing the canyons of Utah, but I sell very little. However, I've spent relatively little time photographing the Saguaro cactus in southern Arizona, but have met with considerable success. What else defines the American Southwest better than the Saguaro cactus?

"I look at stock as a long-term commitment and try to envision what I'll have to show for all my work and investment after twenty to thirty years. I hope to have a body of work that is timeless and valuable. Now this is referred to as "content." If you shoot just what the stock agencies want, such as contemporary, model-released people, it can have more value in the near term, but it may have little value in five years. It will have value to you either as income or as defining you as an artist. I ask myself, Will anyone want to look at this stuff in ten years?"

Richard Weisgrau, Executive Director of ASMP (the American Society of Media Photographers), *www.ASMP.org*, points out: "Over the next five years, stock photography will complete a metamorphosis that started in the early nineties. Stock images travel a clearly noticeable path. The innovative image is copied and becomes generic; the generic becomes abundantly available, and then it ends up as clip art. We have seen a three-class system emerging for years. It is not the end. It is a transitional state of affairs. Observation shows that the entire generic class of work is quickly being replaced by clip art. In the next few years, this process will be completed.

"We will see innovative photography subject to exclusive and limited licenses, and generic images being the foundation of royalty-free transactions. The middle class will simply disappear. It is almost what is happening in the labor market. There are the high-paid jobs, requiring expertise, and the low-paid, requiring none. Technology has a way of eliminating the middle ground in the micro and macro economic environment. This transition will be mostly limited to the promotional image use. The documentary image use may be exempt from this transition, since it is based upon its storytelling content, which, being factual rather than conceptual, is nongeneric by nature."

IN SUMMARY

Seth Resnick of Seth Resnick Photography, *www.sethresnick.com* adds: "What are you really selling as a photographer? You are not selling anything. You are, in fact, licensing images in the case of stock and charging a creative fee plus use as it applies to assignment photography. The topics that remain hot for commercial assignment work continue to be technology, business, and lifestyle. Ironically or not, the photo market tends to follow the trends of Wall Street and the general trends of the time. From the client's point of view assignment work can be very expensive with no guarantees. Yet the assignment can offer the client exactly what he or she is looking for and it can offer a unique concept exclusively done for a specific client. This can bring a sense of prestige and elitism into an ad campaign. For myself, I always prefer assignment work because it allows me a real creative outlook for my energy. I am a photographer and thus I thrive on every chance to actually shoot.

> **"You are not selling anything. You are, in fact, licensing image...."**

"With regard to Wall Street, the best stocks to pick are probably the ones that you buy for the long-term investment. In stock photography, the images that really seem to be licensed the most are the solid, strong images based on great design and content. Trendier images may command higher amounts of money but tend to have a very short life span.

"From a business perspective the stock arrangement offers much greater income but may not offer the satisfaction. This past week, for example, I licensed a stock image for over $10,000 with really quite limited uses. The entire negotiations took about one hour and yielded a pure profit of over 10K. Business sense tells me that this is ideal, yet I don't really get the chance or the opportunity to show my true creative talents as a photographer.

"A balance between both assignment and stock is really needed to have the best of both worlds."

Chapter 9

MARKETING ON THE INTERNET

EVERYONE WANTS TO KNOW, "HOW DOES A WEB PAGE SELL MY WORK?" AT EVERY seminar I give, someone asks, "How does the Internet market my work?" Keep in mind that the field of Internet marketing is still new technology compared with print marketing. We are all still learning from our mistakes and our success stories. Here are some questions that will help you decide if and how you should make the Internet part of your marketing strategy.

HOW DO YOU DECIDE IF YOU'RE READY?

It is no longer "Should you be using the Internet?" The better question is "How should you be using the Internet?" Everyone wants to be on the information superhighway, but you need to know where you are going and why. Is it to create name recognition or a global presence? Do you want to sell your work as stock images? Will you expect clients to contact you for more information? Call you for jobs? Sign up to be on your mailing list? The first step is to set some goals for a presence on the Internet so you can design a Web site with these goals in mind.

IS YOUR SITE AN AD OR A PORTFOLIO?

With a well-designed home page, your site should work as both an advertisement and as a portfolio. Usually, the objective of an ad is to make an impression and get the photography client to respond, seeking more information. Usually, the objective of a portfolio is to deliver that information.

Use a home page with information that downloads quickly. It should bring clients from the search engines, capture their attention, and then show them what to do next (it's an ad). With thumbnail photos or even a text description, the prospective client can click to her area of interest (it's a portfolio).

The best sites avoid having long download times for the first page and avoid extensive scrolling down to reach your images or information. Also, if you don't have a way to identify the people who respond, you can't build on that response (now it's a lead development tool!). Of the photographers interviewed for this book, most agreed that this hybrid is now an entirely new addition to the marketing mix and does not replace any other marketing tool.

WHERE SHOULD YOU BE ON THE INFORMATION HIGHWAY?

You will probably be best served by having a listing or page on a "portfolio" Web site with other professionals *and* having a site of your own.

Existing online sourcebooks or directory sites have the advantage of handling all the marketing to bring the traffic and get clients to come to the site. This is an often-underestimated task. It is actually very time-consuming and expensive to build an on ramp for traffic to your Web site. The existing sites have already registered with the major search engines, market by direct mail, and are listed in print sourcebooks. Check for ones with the big advantage of a URL that is easy for clients to use and remember.

On your own, you have to do all the work to promote your URL and get clients to come and visit. With both, you can build marketing equity when clients get to know your name and your work, and return to visit both sites. As with any of the traditional marketing tools, success is based on the frequency of multiple exposures to your marketing message.

HOW DO YOU DESIGN YOUR SITE AND GET PROFESSIONAL HELP?

Internet marketing can give you a competitive edge or be a marketing black hole. The very idea of the technology does not replace the need for the basics. You must first have a compelling purpose for clients to visit your site. What they will do once they get there we will cover in a moment. To help define

your purpose, first, define what you are selling. Second, identify your client base and how they make photo-buying decisions. Third, look at factors that will help them make the decision to work with you. Now you are ready to design your site or (better) hire a professional Web designer.

A Web site is not just a digital version of your promo piece or portfolio. The electronic medium is different from print use, yet I still see many sites obviously scanned from printed pages and "thrown up" on the Web site. As photographers, you do not need to learn extensive Web page programming but you do need to work with a design professional with a least a few years of success in Web site and page design.

Note the use of the word "success" because simply having years of design experience is not sufficient. You need to work with a professional with happy and satisfied Web site clients! Start with your local ad club or chapter of AIGA (American Institute of Graphic Arts). Look at awards annuals such as *Communication Arts Magazine (www.commarts.com)* for their "best of" list of Web designers. Check out the resources of *Target Marketing Magazine (www.targetonline.com)* for their resources directory that includes graphic designers for Web sites.

John Blair of John G. Blair Studio, *www.jgblairphoto.com*, offers some design criteria that have worked for him: "Put your name and contact information at the top of each page so it has a consistent look and it makes it easy to contact you. If they print out a page, all of it (studio name, phone number, e-mail address) is on the printout. I think it is very important to have your own domain name. It is a sign of success and reliability (you should be able to afford the $35 per year for a domain). Try to avoid large photo sizes so they download quickly and make sure the quality of the scans (sharpness, color, dust spots, etc.) is very good. Put your copyright notice and Web site address on every photo so that people can contact you later if they happen to have saved the photo.

> "Put your name and contact information at the top of each page so it has a consistent look and it makes it easy to contact you."

"Every market is different, but my clients tell me, 'No sound files or other "cool" but annoying effects.' They are looking for information and want it fast. They don't want the 'cool' stuff. I will continue working on my Web site, since it can always be improved upon by asking my clients what they liked and didn't like about my site. With enough information, I can continue to improve it."

WHAT MAKES A WEB SITE EFFECTIVE?

Use this checklist when working with your design professional. Remember: A Web site is first and foremost a promotion tool!

■ What is the call to action that you will use? How will that action be implemented? It is important to give photography clients options, such as an e-mail response, a toll-free number to call, and a fax number to request more information, or just a guest book to sign. It is very important to try and capture information such as firm names, addresses, phone numbers, and e-mail addresses. We have the technology, use it!

■ What keywords will you use for your metatag page? Be sure to list at least twenty-five to fifty keywords. Do you have all the fields of description copy required when you register your site with the available search engines? Some search engines use your metatag keywords; some use your home page text to search. Study carefully before you decide what text you will supply. This will determine how high up you rate in a typical search. You want to make it into the top ten "matches!"

■ Make the page easy to use. Design with easy-to-read fonts and backgrounds that are not so animated that they interfere with the text. Try for a low contrast between the background color and the text so that is easy to read but can still print out as legible copy. (Author's note: I lost count of how many photographers' Web sites I visited only to abandon the site because, when I tried to print the contact information page to keep on file, it came out illegible.)

■ Use a "home" page that allows photo clients to explore without getting lost or sidetracked. Too many "clicks" to get to their choice takes time and can be frustrating to a visiting client. Add links that zip clients to places on your site rather than have them scroll and scroll or click until they get bored and leave!

■ Discuss technical issues with your designer, such as site navigation, file size, download time, color depth and palette (to name just a few). As with print promotions, there can be a conflict between "make it pretty" and "make it work." Be careful with designs that slow down the navigation of your site.

■ Use the unique factor of the quick speed of electronic response time to test different offers, calls to action, and other response mechanisms. Ask for feedback and be open to learning. Faster than print promotions, you can quickly turn around a test, get feedback, and make any changes.

■ Find ways to add interesting content to your site. By using "editorial" side by side with your "advertising," you will give your clients a reason to revisit your site. Try a chat room, a survey, or a contest. Use any techniques you can think of to create interest and interaction. This requires a lot of maintenance but will boost your site's reputation, recognition, and client loyalty.

■ Strive to establish a dialogue with your clients. Respond to their requests quickly and always plan for follow-up. Be personal and personable. You are dealing in a cold, impersonal medium, so try to warm things up. Decide with them when will you next be in contact with them. You are in charge of what happens next.

HOW DO YOU ATTRACT CLIENTS TO YOUR SITE?

First of all, a Web site will not take the place of a marketing plan; it must be an integrated part of your marketing plan. There is too much at stake to wait for clients to stumble across your site! Photo clients cannot easily come looking for you unless you let them know exactly where you are. You will still need to use many of the traditional print marketing tools to promote your site.

■ Be sure to add your URL to everything you print, including business cards, letterhead, envelopes, mailing labels, logo labels, note cards, photo print labels, slide captions, estimates, invoices, all promo pieces, mailers, and ads, as well as in every outgoing e-mail (use the signature block).

■ Register with Internet search engines, general directories and photo-specific directories to announce your Web site as soon as it's published. Remember: Some still take up to eight weeks to include your Web site.

John Blair adds, "I list my business in every free photographer e-mail list that comes my way. Most are e-mailed to me or I hear about them in online discussion groups. There are so many free listings for photographers that I don't need to pay for a listing. Also, make sure that you are a member of at least one or more professional photography organizations. Check your online listing at the organization's Web site to verify that it is correct. I get a number of jobs that way."

■ Write both print and electronic press releases to submit to the appropriate media to announce your Web site.

■ Obtain links from other Web sites that relate to your marketing message.

■ Make your content relate to your marketing message and use the site as a portfolio.

■ Ira Gostin offers this thought: "For us, the Internet is a sales tool. We send people, through phone conversations and direct mail, to our Web site. For us, the Internet simply closes the deal faster, and saves a lot on portfolio shipping charges!" Update the site often and be sure to keep the "Last updated" date current.

A written marketing plan is the best way to coordinate your print and electronic self-promotion and achieve your marketing goals for your Web site. This plan will coordinate the elements of both timing and consistency between your print and electronic efforts. To find out how to write effective marketing plans, see chapters 20 and 21.

In conclusion, here is a case study of an Internet marketing start-up created by **Mark and Lisa Graf**, owners of **Graf Photography,** *www.grafphoto.com.* Mark responded to the following questions.

How did you decide to market on the Internet?

The Internet has essentially opened doors to photographers to self-publish their work at relatively little expense and effort, both professional and amateur. We recently took advantage of the Web space offered by our Internet service provider to self-publish our work and let people know what we have to offer. Despite now being on the Net, we don't expect people to start hitting our site by the thousands. The Internet has grown to be such a vast place; you still need to promote your site to be found. Just because it's there, it doesn't mean people will visit it. We started with a short launch announcement to just about everyone in our address book, listing on search engines, and adding links on other photography sites. We are continuously looking for ways to spread the word and encourage visitors. Another benefit is you have a portfolio that is instantly accessible by anyone in the world. We are exploring the ways this will help us in communicating with editors and potential clients.

"Just because it's there, it doesn't mean people will visit it."

What design criteria did you use for your Web site?

Our site is relatively new and, before it was developed, a lot of time was spent visiting other photography sites to see what they had, how they were laid out. There are a lot of personal preferences, but the simple layouts and nicely designed pages seemed to stick in our minds the most. We tried to keep a common theme throughout our site, mostly with the use of our logo, and variations of it to help people remember us. We tried to blend an artistic appearance that is not overly complicated. We want to make navigation as easy as possible, easy for people to find things. One area we are developing is the e-commerce aspect of the site. In this one-click ordering world, we would like to offer prints available with this ease. At this time, we are investigating the best methods to make this happen.

What Web sites do you use for free listings?

Many sites offer links to your site if you add a reciprocal link to theirs, a fair trade and often a compliment. Many are directory type-sites with a concen-

tration on photography. A couple we have used are *www.naturepix.com* and *www.naturephotographers.com.*

What kind of feedback have you received from visitors?

"Overall, I am quite impressed with its layout-design and images. The images have great color. I would hope my Web page could be this good. I found it user friendly, nice graphics and the slide dissolve adds a dynamic touch to the site."

— Robert Parnell, *nature photographer*

"It seems those of us in photography that get involved with this aspect also have a passion for the care of all living things, and your words show that your hearts are in that direction as well. Congratulations on launching your Web page, it's excellent, and I look forward to seeing more of your work."

— Marianne Lease, *Detroit Institute of Arts*

"GREAT logo! I really like the way you tie it in with the 'buttons.' Image size and resolution are good, too, and it loads relatively quickly, making the site fun to look at."

— Andy Richards, *nature photographer*

"Congratulations on the Web site! Looks great. It's great to see someone you know advancing in this Internet era of photography. I love how you have the changing pictures on the first page. You really held my interest as I waited for each subsequent image. Also, I was unaware of your underwater work until my visit to your site. Looks good."

— Mark LaGrange, *nature photographer*

Chapter **10**

WORKING IN THE MAJOR METROPOLITAN MARKETS

IF YOU HAVE ESTABLISHED YOUR PHOTOGRAPHY BUSINESS IN ONE OF THE TRADITIONAL "big city" markets, you undoubtedly have a different type of client base than your peers in geographically smaller markets. To a photographer in New York, Los Angeles, or Chicago—or any major metropolitan city in the world—here are some of the major challenges you will be dealing with.

- The client base is smaller and much more concentrated. Often, this means a much greater level of competition. A large pool of photographers is going after a smaller pool of jobs.

- Because you are in a more geographically concentrated market, you have the ability to be more focused on relationship selling (see chapter 12). Your clients can be "courted" in person and you can do more intensive follow-up.

- Bigger cities have a greater concentration of advertising agencies and design firms. The bad news is that this makes for a very vertical (specialized) client base. The good news is that these jobs are a source of higher value based on use, and they often have a greater volume of jobs due to their larger client (and media billings) base.

- Photography reps are more often found in larger cities because of the

concentration of these high-end advertising agency clients. A rep will develop good relationships with the art directors or art buyers to sell dozens of jobs over a period of time.

MAJOR MARKET PROMOTION STRATEGIES

When you are selling to clients in these markets, you'll find a lot more specialization among photographers. This helps them to stand out from the competition. However, just one or two specialties will not bring in enough billings in today's economy. It may take a number of specialties in a major market to build a recession-proof base as a generalist.

You'll also find that there is a longer time between the first sales call and the first job. This means planning a more aggressive strategy for keeping clients and developing a plan to find the less glamorous bread and butter clients to pay the rent. Many major market photographers add profit centers, such as stock photography, giving workshops, or writing articles and books!

Multiple layers of marketing are very important in a larger market with lots of competition. You'll probably need marketing coordinators to assist with your business and the administrative aspects of promotion (see chapter 18). You'll find more requests for drop-off portfolios and mini-portfolios. Your direct mail will need to be much more sophisticated than throwing your promo piece in an envelope!

Add Value

Figure out how to add or create value instead of cutting price to get a job. Perhaps it is your studio location or your experience with models. Maybe it is your patience with long, tedious shoots. What makes you special? Help the client hire you. In these major markets (as in any market), remember that you must first be a business owner, then a photographer. Clients will treat you in business exactly the way you train them. If you act like a business owner, you are more likely to get treated like one.

Who Are They Buying For?

Major market ad agencies and design firms have more "consumer"-oriented clientele and are more sensitive to growth industry trends. Be sure to review such publications as the *Wall Street Journal* and *American Demographics Magazine*. Look to the futurists and trend forecasters such as TrendWatch (*www.trendwatch.com*).

Know before you show a portfolio or mail a promo piece what clients the agency buys photography for. The traditional consumer clients of these ad agencies are changing to reflect changing demographics. They break down into smaller, more targeted markets. Some of this breakdown includes: the 50-plus

age market, the "Y" generation baby boom, ethnic diversity (particularly the Hispanic consumers) high-tech related to health care or environmental issues, small retail entrepreneurs, business services (such as payroll or personnel agencies), leisure and travel, telecommunications, biotechnology, Internet technologies, and e-commerce businesses.

In-House Ad Agencies

At the end of the decade and into this year 2001, more corporations based in the major metro areas have taken their marketing and communications services as in-house ad agencies (sometimes you will find them called creative services departments). Many photographers find them harder to research, but they are well worth pursuing. The in-house client often has its hands on the photo jobs in such diverse media as Internet marketing, print ads, trade shows and exhibits, direct mail catalogs, and sales promotions.

More Image-Based Communication

Finally, the major markets are most sensitive to the recent shift from text-based communications to image-based communications. Clients in these major metro markets need your images to tell their story, to sell their products and services. With the growth of stock photography use, e-commerce, and direct mail marketing, your potential clients in these markets will consume an enormous amount of images. So go get the work!

RESEARCHING NEW CLIENTS

O NCE YOU HAVE DECIDED ON YOUR SPECIFIC MARKETING MESSAGE (SEE CHAPTER 2), it will provide the direction for your research. You will look for new clients in three steps: the primary research to build a database, the secondary research to upgrade and maintain new lead development, then turning each lead into the name of the true client you'll be selling to—your "prospect."

For commercial photography clients, it is very important to use all three steps. It is especially important to research so you can knock on the right doors. Selling to commercial clients who do not buy the type of work you want to do is a waste of their time and yours. If you repeatedly try to sell to clients who do not use your type of photos, you will be rejected constantly.

While commercial photographers go out and knock on *clients'* doors (selling), the consumer photographer is more dependent on the reverse. Your wedding and portrait marketing plan of advertising, Web sites, and direct mail must be designed to bring clients to *your* door, and then you can sell to them. For consumer photography clients, there are no precise directories to research of

"people who want a family portrait," but you will certainly want to use the third step of turning a lead into a prospect.

PRIMARY MARKET RESEARCH

Most of the research for commercial photography clients will be done at your public library or online. The librarians in the business reference section will be most helpful when you can tell them what you are looking for. From manufacturers to advertising agencies to book publishers, there is a directory for every market! Before you spend hours at the library copier with a pocketful of change, check with the publishers to see if the directory is available on CD-ROM or online. Then, you can download the data into your personal computer and use the information for making sales calls or mailing labels.

Look for directories that have some kind of qualifier for a firm to be listed. When you are looking for new clients, you want to work with the highest level of information possible. Some directories will list book publishers simply because they exist, while others will list only book publishers that answer an annual survey of what kinds of photography assignments are available. Check it out!

Here are some commercial client research sources:

Advertising Agencies

- Standard Directory of Advertising Agencies (*www.nationalregisterpublishing.com*)

- Adweek Directory (*www.adweek.com/directories*)

- Agency ComPile Web site (*www.agencycompile.com*)

- ADBASE Creatives Web site (*www.adbasecreatives.com*)

When looking for advertising photography assignments, there are two ways to research prospective clients. In the first one, you are selling to an advertising agency based on the type of clients they represent, such as selling food photography to an agency with food clients. Even subject categories as broad as people or product photography can be broken down into specific client types. For leads on people photography, you will look at ad agencies that have "service" sector clients such as health care, financial, or insurance.

For product photography, look at agencies with "manufacturing" clients, such as manufacturers of computers or electronics. True, you do see people in computer advertising, but when doing primary research you are taking your best guess at the most likely leads for the work you want to do.

In the second one, you can sell your personal style to an advertising agency. This kind of client is not specific to any industry or subject category.

You can make an educated guess, however, and take a close look at agencies with consumer advertising clients and ad agencies winning creative awards as more likely to use "style" in their advertising photography.

Corporate Clients (also called Client Direct)

- Standard Directory of Advertisers (*www.nationalregister publishing.com*)
- Chamber of Commerce Directory (See your local county chamber of commerce)
- Brandweek Directory (published by Adweek; *www.adweek.com/ directories*)
- Services Directory/Manufacturers Register (HarrisInfoSource, 800-888-8434)
- Business Journal Book of Lists (one in each major city area)
- Encyclopedia of Associations (by industry; Gale Group, *www. galegroup.com*, 800-347-4253)

These are just a few of the dozens of directories that list the names of companies to develop into photography leads. Watch for qualified information, such as a chamber of commerce or an industry association directory (companies have to be members to be listed). Again, the value of this level of information is that it "weeds" out the less aggressive companies and leaves you with firms that are actively promoting their products and services. What can you guess from this qualifier? They are probably doing more promotion and need more photography!

Direct Marketing

- Directory of Major Mailers (*www.targetonline.com*)
- Direct Marketing Market Place (*www.nationalregisterpublishing.com*)

Direct marketing agencies are firms that are responsible for the design and production of promotions—primarily direct mail. Since so many companies have found direct mail more cost effective than some forms of print or electronic advertising, millions of dollars in marketing budgets have been taken away from ad agencies and given over to direct marketing agencies. This is particularly good for catalog and other consumer photography projects. Books like the *Directory of Major Mailers* are available on a CD-ROM so you can search by company name, industry category, or geographic area.

Editorial/Magazines/Publications

- Standard Rate & Data Service (SRDS, 800-851-7737, *www.srds.com*)
- Gebbie Press All-In-One Directory
- Gale's Directory of Publications
- Editor Publisher (newspaper directory)

Though the photo fee rates are usually fixed by the publication at a "page rate," many photographers pursue editorial because of:

*The credibility conferred by having published work

- The contacts they can make with corporate clients

- The creative freedom these publications offer photographers to pursue their personal style

Be sure that before you pursue editorial clients you have thoroughly read and reviewed copies of the publication so that you are familiar with its style— what the publication calls its "focus"—and the direction of its photography needs. Some are cutting edge; some are conservative; know who you are selling to before you knock on the door!

Graphic Designers

- *The Design Firm Directory* (Wefler & Associates; 847-475-1866; *www.wef.net*)

- *The Workbook* (Directory Section) or (*www.workbook.com*)

Design firms are wonderful clients for photographers! Like ad agencies, they work with the projects a company feels can't always be done internally. Like editorial clients, they work very collaboratively with their photographers and often use the photographer's perspective. Their photography projects often have extensive shot lists, such as an annual report or a Web site. Sometimes their photo needs are regular and seasonal, such as catalogs. Though more difficult to research and less visible than an ad agency, they are very good clients for repeat business.

Paper Products/Book Publishers/Record Album Producers

- *Photographer's Market* and *Writer's Market* (Writer's Digest Books, *www.writersdigest.com*)

Paper products are a subject-specific market but also great for stock (concept) photography sales. This category includes publishers of calendars, greeting cards, posters, and other novelty products. In this market category, photography projects or assignments are often purchased on a small advance-plus-royalty payment plan. Be sure to have your attorney or a reliable agent look over any contract before you agree to the use of your work.

Buying Compiled Information

- The List (404-814-9969, *www.thelistinc.com*)

- Gale's Directory of Databases (800-347-4253, *www.galegroup.com*)

- Creative Access, 312-440-1140 (*www.bigroster.com*)

- Target Marketing magazine (215-238-5300, w*ww.targetonline.com*)

The above firms are just a few of the resources available for the purchase of information compiled from telephone surveys, credit card purchases, magazine subscriptions, and association memberships. Buying information is always more expensive than the purchase of a simple mailing list, but the quality of the information is higher and more qualified.

SECONDARY MARKET RESEARCH

Once you have set up a primary database, here are some additional resources and new areas of communication and promotion for developing new leads in your photography business.

Daily Newspapers

Every day, in the business section of daily newspapers, you will find news released by companies that includes: new products, expanded services, changes in personnel. Any of these are opportunities for you to get in the door with your photography services.

Trade Magazines

Check in the periodicals section of your library reference. You'll find magazines for every possible industry and trade. These publications, much like newspapers, include news releases that are specific to the area of photography you're interested in. You may even want to get the information to subscribe in print or online so that you can use them for contacting clients for photography services on a more regular basis.

Trade Show Exhibitors' Guides

Every industry also has some kind of annual trade show. The value of this research is that those listed in the guides are prequalified for buying photography. Many companies choose not to participate in their own industry trade shows. It's a good bet that the ones that do participate will need more photography for brochures and displays than their competitors that have stayed home!

Editorial Calendars

When researching any kind of publication for photography services, the editorial calendar identifies the issue-by-issue articles for the year. Keep in mind that magazines work three to six months ahead of publication date. With the information from the editorial calendar, when you approach the publication (see chapter 12), you will be able to reference your work to a specific need the editor will have for photography for an upcoming issue! You can get the editorial calendar by calling the advertising sales department and asking for a media

kit or by talking to the editorial department secretary. Remember: You are still in the research stage (not selling anything yet) so that you do not need to talk to a client or decision maker.

Awards Annuals

Finally, when you have a very strong visual style, you'll find that the clients that buy style tend to win the creative awards in their industry. If a client used a strong photography style once, he is more likely to do it again! Research these clients by reviewing advertising and design industry award directories from trade associations and from publications such as *Communication Arts* magazine and *Applied Arts* magazine (Canada).

New Media Clients

For this entirely new type of photography client (see chapter 8), let's talk with Tony Luna and Harry Liles of New Media Marketplace. Tony says, "The best thing about being involved in a marketplace that defines itself as being 'new media' is that you are always creating new methods for promotion for yourself and your clients based upon the latest technologies and points of view. The most challenging thing is that you can't afford to be too far ahead of the curve or else no one will comprehend what you have to offer; and you can't be the slightest bit behind because you lose your credibility.

"Our new media clients want to be seen as being risk takers in an aggressive market. But for all their hubris, in actuality, they are 'calculated risk takers.' They need to know that someone else took the first chance and did not get burned. 'The first one over the hill gets shot' is more than a cliché in the promotion environment. Therefore, we have been creating immersive digital media for our clientele that make the technology work easier and with a broader approach. Every time you pick up the paper, or turn on the radio or TV, there is some new technological miracle being touted. But if the application is not self-supporting, the message never gets across. When talking to my clients about the problems they are addressing, the first thing we have to do is understand where they want to go and how we can help them get there. Again, the basics come into play. We can't allow ourselves to get too enamored with the technology and overshoot the audience.

> "I see more strategic alliances between potential clients as they aspire to capture a larger market share."

"I see more strategic alliances between potential clients as they aspire to capture a larger market share. In achieving that goal, they will unify print, broadcast, and interactive media. That will dictate that the artists that create the advertising and promotion will have to be savvier in developing ways to go beyond the traditional media. For example, we are creating business card CD-

ROMs for the dot.com companies and for business-to-business applications. Even a small company can have a global presence if it has a unified and comprehensive approach to its promotion. And as a company captures a vertical market, it can spread out and eventually be a major player by joining forces with companies that used to be competitors but are now cooperators in widening their services. And just think of it: All these people need someone to help them promote themselves."

QUALIFY LEADS INTO PROSPECTS

In this final stage of research, your objective is simple. You will call to get the name of the true client, the person in charge of buying photography. Since this step is still research and not selling, it is very easy to delegate to your marketing coordinator or studio manager.

You can start by using the role-play scripts below to get the most information with the least amount of effort. It is very important to prepare ahead for even the simplest verbal interaction! You have

"It is very important to prepare ahead for even the simplest verbal interaction!"

no time to waste or to frustrate a client because you don't know what question to ask. Be sure to be specific as to the type of photography work you are looking for (your marketing message) so that you will get the correct contact name. You can use the variations depending on whether you are calling a company or agency of some kind. You can even use job titles if you have the correct title information in advance.

Your Phone Call Script for Finding and Qualifying New Client Leads

"Hello, my name is _____ from _____ company and I'm just updating our files. Who is in charge of hiring for (fill in with a specific type of work) photography?"

(*Answer:* Mary is in charge.)

"Hello, my name is _____ from _____ company and I just need information on your company. Who is responsible for hiring the (fill in with a specific type) photography services?"

(*Answer:* Mary is responsible.)

"Hello, my name is _____ from _____ company and I'm just updating our files. Who is the art director for the (fill in with a specific client name) photography?"

(*Answer:* Mary is the art director on that account.)

Then, say thank you and hang up! If you have been successful in getting the name and that individual on the phone in one phone call, don't fix what is

not broken. Most of the time, you will find a higher level of success by simply separating the two steps.

With this information, you can now decide how to proceed, based on your final marketing plan. You can approach the contact person for an appointment or for information (see chapter 12).

You can add the name to your mailing list database (see chapter 19). The information (the name of the prospective client) is the key. Get that first!

Chapter **12**

STEPS
TO
SELLING

NO MATTER HOW GREAT YOU ARE AS A PHOTOGRAPHER, AT SOME POINT YOU HAVE to talk to people. To get appointments, close a sale, follow up—all require verbal contacts with your clients that you might not feel comfortable making. After all, if you were good at talking with people, you would have probably gone into sales, not photography! You may have the greatest promo piece or direct mail campaign, but you still have to talk with clients. Unfortunately, this is not a skill most photographers learn in school. Too bad, because it is one of the most important business tools next to your camera! You may feel it is ridiculous to write everything down that you are going to say, but photographers who have switched to scripting have been very successful. You may want to set your feelings aside and just try it.

Talking to clients shouldn't be done without some preparation because you want to make the best use of your time, get more information about what clients want, and have the best chance to get the work. If you are happy with

the amount of business and the type of photo jobs you are getting, stop reading here. After all, if it isn't broken, don't fix it! This chapter is for those of you who want to get more out of each contact you have with a client.

In this chapter, you will learn how to talk with clients, get information and appointments, deal with the ever-present voice mail system, and make effective and job-getting portfolio presentations and follow-up calls. The best preparation for any kind of phone call or conversation with clients is called "scripting." This is simply a process of writing down the expected interaction between you and your client. You need to do a careful, thorough preparation, just as you would prepare before going out on any photo shoot. Preparing scripts in order to get portfolio appointments and do follow-up is the most useful marketing tool you can develop.

Start by writing down the anticipated conversation, as you would like it to go. Be sure to plan for all variations. In other words, no matter what a client's response, you have anticipated your reply. Not only will this technique help you get more out of every call, but you will approach the entire chore of "selling" with more motivation and inspiration. You may even like it!

STEPS FOR SCRIPT WRITING

Step #1

Open with a brief and specific introduction of your services. First you get people's attention, then you tell them what you want. For example, "Hello, I am a food photographer and my name is _____. We are interested in the XYZ Restaurant's account and would like to show our food portfolio to you this week. When would be a good time to come by?"

The first key phrase is "food photography" and that allows the clients to more accurately "picture" their need for your work than if you had just said "I am a photographer."

The second key word here is "when" because it gives you more options in terms of having a conversation than if you had asked the closed question, "May I come and show my portfolio?" (See step 4 below.) The easy answer to that question is *no*, and the client will not take the time to seriously consider your request and his needs if you ask a closed question.

Step # 2

Through your research, determine what the client does or needs (see chapter 11), and then decide what portfolio you will talk about. Talk portrait photography to portrait clients, corporate photography to corporate clients. What you do as a photographer depends on whom you are talking to. Clients only care about what they need!

Step # 3

Come up with something interesting. After all, you are most likely trying to replace another photographer the buyers are secure with. Why should theyswitch? For example, "Have you seen our digital background samples?"; or "Our style of photography has helped our clients sell more of their products"; or "We offer consultations for those clients making the switch to digital services. When would you like to schedule your consultation?"

Step # 4

Always use *open questions* that begin with "How, Who, What, When, Where, and Why" instead of closed questions that begin with "Can, Could, Would, Do." This is to encourage your information gathering, save time, and reduce the rejection that comes with the no you get when you ask a closed question. For example, when showing your portfolio, ask these open questions to get information, confirm the information, and verify agreements you have reached:

"How often do you use a different photographer?"

"What other photography needs do you have?"

"When will you be looking at bids on that job?"

"Who else in the office buys this type of photography?"

Step # 5

Anticipate objections and questions about your services and have very specific information you want to acquire. *Never* hang up the phone without achieving some specific objective. Get an appointment, a piece of information, anything! Successfully accomplishing your objective keeps you motivated to do this day after day. For example, when you want more information from the client, ask:

"When would be a good time to check back on that job?"

"How do you feel about a follow-up call in three weeks?"

"What will you be looking for in the bids on that job?"

"Who will have final approval on the photographer?"

WHICH APPROACH TO SELLING IS RIGHT FOR YOU?

Traditionally, photographers have approached commercial clients for an appointment to show their portfolio. Later in this chapter, we will talk with photographer David Rigg about approaching consumer clients.

In today's competitive marketplace, getting personal time with the commercial client has been getting more and more difficult. Clients are too busy, pressed for time, and stressed with change. Certainly an appointment to show your work and begin a relationship still works, but what if you can't get in the door? What if you have so many prospective clients that seeing every one of them will take forever to generate assignments? You may want to approach a client to gather information rather than setting up an appointment as your primary objective. Let's look at your choices.

You already have the name of the client, Mary, from your research (see chapter 11). Now, you have two choices for approaching prospective clients: "relationship" selling, where you are seeking an appointment first, and "needs" selling, where you are first looking for more information regarding the client's needs before you try to get the portfolio appointment.

Here's how the two types work. Please note that every script shown below is specific to the type of photography, which is your marketing message that you are selling. In these scripts, you will see "food photography" as the subject-specific marketing message. Replace it with your own message!

Relationship Selling to Get the Appointment

Step #1

Ask for your client contact by name: "This is Maria from Creative Services. May I please speak with Mary?"

Step #2

The receptionist usually asks, "What is this regarding?" and your response should revolve around your specific marketing message (see chapter 2); that is, what type of photography you are selling. The more specific the message, the easier it is for your prospective clients to decide or "picture" whether they need or want to see you and your portfolio at this time.

So your responses could be:

"It is regarding an appointment to discuss her food photography needs."

"I am calling regarding the food photo promo she received (if you sent one ahead)."

"I was referred by John Smith, who recommended our food photography portfolio to Mary."

Step #3

Simple. No matter what words you hear back, there are only two responses. If you reach Mary, you will either get an appointment or not! You can proba-

bly tell when you are getting the appointment. It will sound something like, "Yes, let's get together."

It is the other response that can be confusing. Comments such as, "She is in a meeting" or "She can't come to the phone" all mean the same thing. They are saying, "No, we're not looking at food photo portfolios at this time," which just means, "No, not now."

Step #4

When you get this second response ("No, not now"), do not get off the phone without a piece of information that you can recycle back into another contact with your prospect. Pick any of the below or make up your own. Just don't quit at this point without knowing what happens next. Your possible responses when you hear a "No, not now" could be:

"Who else can tell me about your food photography needs?"

"When to call back for an appointment?"

"What would be the best time to reach Mary?"

"Who else in company may use food photography?"

"What kind of needs for food photography are there?"

"How often does your company work with a food photographer?"

How Voice Mail Works *for* You

First, voice mail is your friend and stop hating it so much. It allows you to leave a clear, specific message, and it allows the client to work without interruption and deal with all the phone calls she gets at one time. Now, because your voice mail message is heard as one of many incoming calls, it is important to start your voice mail message with the *what* and not the *who*. This is especially true for prospective clients and less critical for your regular clients.

For example, this is not a good voice mail message: "My name is Maria from Creative Services. Please return my call (and leave your area code and phone number)." Not only does the client not know who you are, he doesn't know what you do or why he should bother calling you back. If you leave, a good, complete message, you can feel confident that you did your best to pique his interest.

Try this instead: "I'm calling regarding your food photography needs and when you want to see my portfolio, please call back. My name is Maria from Creative Services at (then repeat your area code and phone number twice)." Easy on the client, less stress, and she only needs to call back if she needs your type of photography right now. If she doesn't call back in response to this script, you can safely interpret the lack of response as "No, not now."

Information Selling to Determine Needs

This approach starts out the same way as appointment selling.

Step #1

Ask for contact by name, "This is Maria from Creative Services. May I speak please with Mary?"

Step #2

The receptionist asks, "What is this regarding?" This time, your response is to seek out more information so that you can determine if you *want* to ask for an appointment. This sifting of clients is useful when you have a lot of leads or simply want to save everyone's time and just make appointments with the clients who are ready to work with you. This approach results in fewer portfolio appointments, but each appointment is to discuss a need for photography. Here are some of your responses:

"We're just updating our files. What kind of need does Mary have for food photography at this time?"

"We just need some information. When will Mary next be reviewing food photography portfolios?"

NOTE: Always use your marketing message ("food photography") so the client knows what type of photography needs you are talking about.

Step #3

If the response is positive, then go for the appointment. If Mary doesn't need food photography at this time, simply ask when you should check back. If this is a client you really want to work with, suggest that you'll send your mini-portfolio for Mary to keep until the two of you can get together.

EFFECTIVE JOB-GETTING PORTFOLIO PRESENTATIONS

Finally, you have the appointment and want to make the most of your time with your prospective client. There is no way to "script" a personal presentation of your portfolio, since each one will be customized to the client's needs and his responses to your work. Instead, you can be sure to cover the following points in order to make the most of your time together.

Step #1

Have an introduction that helps the client focus on who you are, what you do, and why you are there.

Step #2

Present your images from the clients' perspective of the value to them, not of the images themselves. Don't talk about what the image is; clients can see

what it is for themselves! Talk about *how you got there*. You don't need to talk a lot or to talk about every image, but be prepared to have something to say to help the client decide to work with you. The image will sell itself, but it doesn't say a lot about you. Clients tend to hire you for how you think, how you solve problems, and how you put the image together. These are called the "benefits" of working with you.

Step #3

Be prepared for hard, tough questions. If the client isn't asking you about price, experience, other clients you have worked with—all the hard, tough questions—then he is not very interested in working with you at this time!

Step #4

Leave behind some type of promotion material for the client to (hopefully) keep on file and to help the client remember what you can do for her. See chapter 5 for promotion pieces to leave behind.

Step #5

The most important step, and the entire reason you are meeting with this client, is the follow-up. It is to find out what happens next. This step can use a good script. Choose any of the questions below to conclude the meeting or phone call. *Always* take control of the follow-up; it is not the client's job.

"When should we get together again?"

"What work would you like to see more of?"

"When should I call you back about that project?"

"How about a call next month?"

"How do you want to keep in touch?"

"When should I send more information?"

Step #6

As you are packing to leave, ask for a referral with an open question, "Who else do you know who may need food photography?" Again, use your marketing message (food photography) and be specific.

ADDITIONAL SCRIPTING FOR PORTFOLIOS

Portfolio presentations can't always be scripted word for word, since they will be customized and personalized to the specific client and photography they need. However, you can be careful to use the open questions technique discussed above to get information, confirm information, and begin to develop the critical follow-up relationship that leads to jobs. There are a few "open" portfolio presentation questions you can ask that will help you to set the priority of follow-up for this particular client:

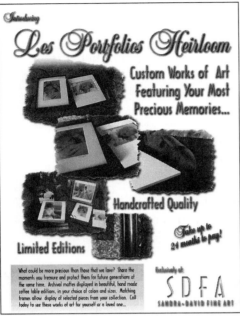

Figure 12-1

Figure 12-2

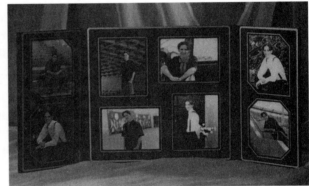

"How often do you use different photographers?"

"What other photography needs do you have coming up?"

"When will you be looking at quotes on that job?"

"Who else in the company works with photographers?"

Don't expect these new techniques to feel comfortable at first. Anything you haven't practiced usually is quite uncomfortable at first. You will feel like you are being blunt and too aggressive. You are not! What you are actually doing is *pulling out the information* needed to develop the relationship and get the work instead of *pushing* yourself.

Finally, scripts do not have to be elaborate but they do have to be planned ahead and written down with all possible responses (yours and the photo buyers') indicated. It is simply a matter of thinking through what you want to communicate and what you want to learn from the other person. You will find your communications and presentations not only easier, but also more effective. If you have ever completed any phone call or meeting and thought afterwards, "Why didn't I think of that?" or "Why didn't I mention my new portfolio?" then scripting is your answer.

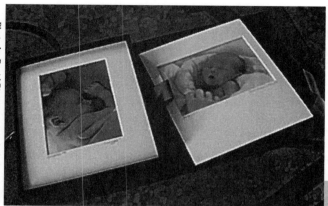

Figure 12-3

Figure 12-4

Figure 12-5

A CASE STUDY:
SELLING TO WEDDING/PORTRAIT (CONSUMER) CLIENTS

By David G. Rigg

First off, we need to distinguish the sequence of events that will normally take place in the retail/consumer selling cycle and examine the radically different tools needed for each phase of the cycle. Because we are generally working on speculation and assumption, we are not really closing the profitable part of the sale until well after the client has hired us. Also, the fact that the client doesn't really know what they will be spending makes the process entirely different from the commercial photographer who must make the sale and then put a price on an estimate, directly from the portfolio itself. We portrait photographers do have the advantage of making the photographic experience itself a powerful sales tool (see figures 12.1, 12.2, 12.3, 12.4, and 12.5).

The goal is for the client to be writing you a check at the end of the presentation, not asking if "you have anything else" for him to look at.

> "Every phase of your contacts with prospects and clients should be scripted, rehearsed, and become second nature."

If that happens, kiss it off to experience, because the client has failed to be persuaded and it's over at that point. Also, if the client says, "We'll get back to you" and thanks you for your time, with few exceptions, that is a clear signal that the buying decision has been made. Unfortunately for you, it was not decided in your favor. Go back to the drawing board and work on that presentation.

Every phase of your contacts with prospects and clients should be scripted, rehearsed, and become second nature. If it works, don't mess with it; if it does not, use some common sense and see where it needs work. Presenting your images to a prospect requires keeping the whole thing in perspective. Religious and philosophical aspects regarding weddings aside, these people are not only throwing one of the most expensive parties ever, but they are also planning one of their families' most important events. They could buy a nice Lexus or make a down payment on a house for the price of this party!

They are under a tremendous amount of stress, and your presentation is going to have to overwhelm them emotionally and get them focused on the benefits of your services and the fact that this is one of the only tangible items they are purchasing. Considering that they will only get to keep three things from the entire investment, (1) each other, (2) their rings, (3) their wedding photographs, anything less than a third of their total budget invested in the photography is a bargain!

Now, let's go back to the bride at the local studio. First off, what concept of our self-respect and talents does she form when we don't show any respect for our own time? Carefully planned presentations should be done by appointment, "Thank you for thinking about Studio X for your wedding portraits! We would love to give you all the information that you need to make your decision about who will be creating your wedding memories. We know how important it is and want to give you our undivided attention. When can you and your fiancé meet with our wedding consultant (who may or may not be you) to show you our wedding photography and answer all your questions? How does Tuesday at 3 p.m. work for you? If your parents are helping you with this, they will want to see what they are getting for their money. Will that time be good for them as well?" Script this step carefully.

Same technique for the query calls: "We want to answer all your questions. When can you come for a short visit? We take our first appointment at X and our last appointment at X. What time is good for you?"

Make sure you will have all the decision makers present. If Mom is paying the bill, she will be flattered that you were sensitive to that fact and

Before a prospect ever touches one of our albums, we have to establish rapport and credibility.

included her. Prescreening these appointments is a really good idea. Time is money. The prospect must be both willing and able to contract your services. I will usually tell them what our minimum is ($5,000) and also let them know what our average client invests with us ($7,000 to $10,000) Then I will politely ask if that is a figure that they would be comfortable with. Most of the time it will end the conversation. That's okay with me because I don't want every job. Learning to "sniff" out the really good clients is a matter of experience and intuition.

In concept, the sales process is very similar to that of the commercial photographer, in that the opportunity to close the sale is a brief one and requires a competent set of sales skills to complement the portfolio itself. Before a prospect ever touches one of our albums, we have to establish rapport and credibility. Multimedia presentations of our imagery give us the ability to totally overwhelm the senses. Sight, sound, smell, touch- all of these elements are the key to creating a total sensory experience that creates comfort and confidence with our services.

Chapter 13

PORTFOLIOS THAT SELL YOUR WORK

IF THIS IS YOUR FIRST ATTEMPT TO PUT TOGETHER A PORTFOLIO, CONGRATULATIONS! You will not be burdened with a lot of preconceptions of what works and what does not work in a portfolio. If you have been in the photography business any length of time, this is probably the part where you ask, "Who changed the rules and how come no one called me?"

For all photographers, your portfolio still provides the focus and direction for your photography business but, because it is so personal, it is hard to be objective. Just because you are tired of looking at an image does not mean it will not do the job and stimulate the people who see it to give you work.

For most photographers, portfolio presentations do not work because they are not "packaged" or planned properly. Many show a collection of images they have done, and hope the consumer or commercial client will find something they want. This is not a multiple-choice test! You must show a portfolio that shouts out your marketing message (see chapter 2) so that any prospective client can retain the visual information and remember *when* to hire you. As much as you may hate to be "pigeonholed" this way, there is simply too much visual information presented to most clients every day. They need your market-

ing message as the "hook" to hang you on and to find you when they need your type of work.

So let's start by redefining the term *portfolio*. A mixed assortment of images is not a portfolio. All these images you have is not a portfolio. Your image files make up a body of work. Out of this body of consumer or commercial photography work comes various portfolios that are *customized by your marketing message* for viewing by a specific client. Each portfolio you pull out of the body of work must also *target the level* at which you want to work (not necessarily the level where you are now).

Another advantage to very polished portfolios becomes apparent when you are looking for a rep. The state of your portfolios is an important consideration when reps consider taking on additional talent. The portfolios really need to be ready to go out the door to be shown to a client now; the rep can't wait months for the portfolio to be ready to show. The portfolios are one of the most important tools for a rep. How will your portfolios show against the competition? What is special or different about them? Do your featured photos have what art directors will respond to in a portfolio? Portfolios that are packaged to *sell* the photographer (and not just show her work) will have a greater attraction for any rep. A polished portfolio also shows your sense of pride, your ability to be consistent, and a strong sense of direction that tells the rep this will be a successful and lucrative business relationship.

PORTFOLIO FORMATS

There are two major areas to concentrate on when planning your portfolio presentations.

First, what you show in your portfolios (image selection) and, second, how you show them (portfolio formats).

Before you do anything else, however, go to your planner or calendar and schedule the time to do this work. Overhauling your portfolios is not the kind of project you can just wait for the time to get around to. Do that, and you will be rushing around at the last minute every time you need a portfolio. That does not work! It should be treated like a real assignment and be given the proper budget, time, energy, and attention.

What You Show

You have certainly heard that you get what you show in your portfolio. So, first you must look at the work you want to get. What kind of work do you want to do more of? Be specific as to the marketing message from chapter 2 (style, subject, industry, use of the images) and to the type of client from chapter 8 (consumer or commercial). Then you can select images and formats for your various portfolios considering both of these factors.

Often, the work you want to do is not the kind of work you have been getting from word-of-mouth or referrals from friends. Paid jobs may not even show your finest work. Photographers often do work with budgetary or creative restrictions that keep them from doing the images they would be most proud to show. The basic rule is this: Don't show this work! Never include a piece in your portfolio just because you got paid for it. It must reflect your best work and your passion for photography.

What if you don't have the images you want to get to show in your portfolios? What if you are making a transition and looking for different types of assignments or just starting out? What about the client who says, "But I want someone who has experience!" Yours is the classic dilemma: "How do you get a job without experience when it takes experience to get the job?"

The answer is self-assignments. People hire you as a creative professional because of what you can do, not necessarily what you have done. So at this step you need to pull out images from your portfolio that don't reflect your marketing message or your highest level of creativity and technical ability. Retire them back into the body of work somewhere. Once that is done (be merciless), you can more clearly see where the holes are in your portfolios that need to be filled with self-assignments.

For example, if you want to do more annual reports, you need to create self-assignments built around the problems and solutions you would find in an annual report assignment. If you want to do more fashion assignments, select a fashion product and produce a portfolio of images to promote it. Self-assignment work is not always the same as personal work. However, it always has a "pretend" client and a problem/solution scenario. To come up with your self-assignments, either work with a client who can supply ideas or collect samples of the kind of work you want to do. Then create your self-assignments from this "ideas file." Be careful of copyright violations! When looking at someone else's work, think in terms of adapting the idea with your own visual solution, not adopting their solution.

For further assistance, try checking with your local photographers' associations. Many of them sponsor annual "portfolio reviews," where you can get your photography portfolio critiqued and evaluated by reps or photography clients. Because it's not an official sales presentation, this review may turn out to be the most honest and open source of feedback you can find!

How You Show It

Consider your target clients. What format are they most familiar with? Don't format your portfolio, and then decide on your target clients. Target your clients first, *and then* format your portfolio. This is not just about what you want to show; it is about what the client wants to see. The target client will influence both the format and the presentation.

How many different portfolio formats will you need for your target markets? Depending on what you are selling and who you are selling your photography services to, you could create as many as four different portfolio formats. Keep in mind that any of these formats can be presented as traditional print or transparency or as a digitally produced format, such as a CD-ROM or Web site. Either way, format to your marketing message—what are you selling, who buys it, and what types of portfolios do *they* prefer to view?

First, the "show" portfolio is your personal portfolio that goes with you to all your client presentations. Many photographers have changed over to using their traveling portfolios instead, as they are making fewer in-person presentations.

Second, when you send a portfolio to an out-of-town client, you will need a duplicate of all the work in the "show" portfolio, but these "traveling" portfolios are usually smaller and lighter for easier handling and less expensive shipping.

Third, sometimes local clients will ask that you "drop off" a portfolio so they can easily evaluate whether they want to see you and your full "show" portfolio. This "drop-off book" is a partial portfolio designed to give the client an idea of what you can do. It should only take a small number of images (perhaps five or six) to help them make this decision, and the images should be bound into some kind of book so that nothing gets lost. Binders or albums also work well.

Fourth, many clients need more than one or two promo pieces to remember what you do and why they should hire you. They need a "mini-portfolio" that they can keep on file or keep in their office. Many photographers today use this popular portfolio format and work very hard to produce a unique combination of concept, design, copy, and photography that becomes a real "page turner" or "keeper" for the client.

One final note: Just because you need a format familiar to your prospective clients does not mean you should not be creative. It *should* be a portfolio that clients want to call and ask for. It could be a logo folder that holds a number of samples and printed promotional materials (a good idea, because they are easy to keep on file), an unforgettable CD-ROM, or a mobile that hangs from the ceiling!

THREE PHOTOGRAPHERS, THREE DIFFERENT PORTFOLIO APPROACHES

Next, let's look at three different photographers. In each case the portfolios they choose use different formats and different technology, based on the clients they are targeting!

JDP Photography: New Approach, New Portfolio

Julie Diebolt Price prepared portfolios for both her consumer and commercial clients. Julie says, "In the last year I have changed my wedding photography style. I had actually sworn off wedding photography until I realized that there were clients who could see my vision and wanted my style of shooting. Therefore, I had to change my 'portfolio' format. I wanted to upgrade the albums I offered, so I invested a significant amount of money in new studio samples that only contained the type of wedding photography I wanted to shoot.

> "I had actually sworn off wedding photography until I realized that there were clients who could see my vision and wanted my style of shooting."

For my commercial photography marketing message, I am currently putting together a mini-portfolio and capabilities brochure that includes the recent commercial work I've done and tear sheets from my previous publications."

New Media Marketplace: The Shift Toward Digital

Tony Luna says, "There appears to be a shift in acceptance of digital portfolios. It is a small shift, but I have detected a significant one in that our target market (ad agencies), art directors, art buyers, photo editors, and the like are becoming more sophisticated and less threatened with nontraditional portfolios. They can 'see' the value of getting an introductory view of an artist's work by looking at thumbnails of a style, which leads to calling in a specific book. If an electronic generation of clients (each generation lasts five to seven years) is what it takes to embrace a new technology, then it is not hard to envision the Junior Art Directors of today requesting attached e-mail images before asking a rep or photographer in to have an interview.

"One art buyer of a major ad agency recently told me her department has gone through a big change as recently as this last year and now reviews online portfolio services, e-mails with links to Web sites, and checks out CD-ROMs (as long as they are self-installing and cross-platform).

"But, as always, the basic rules apply. Do your homework. Know what your prospective client wants. Do some investigation, which includes checking the ad agency's Web site, as well as studying the awards books and trade publications. Then find out how they prefer to see and have reference to your work. No matter how technological we purport to become, the rules still apply:

> "Do your homework. Know what your prospective client wants."

"Show them your best work, which applies to their visual needs."

Sandra David Fine Art, Inc.: Traditional Plus Digital

Portfolios for wedding clients are presented in the form most familiar to the prospective wedding photography client—the album—but there is more to a successful wedding portfolio than your choice of album style! David G. Rigg combines traditional and digital in his portfolio presentations for his studio. David says, "The typical wedding client purchases an album of images created from a body of work that was created from a contractually agreed upon period of time. For which the client generally pays fees for the creation, and then purchases a specific number of prints. Since the albums themselves are generally the finished product, one must show a minimum of at least two albums to have any chance of convincing clients to obligate themselves contractually to use your services (one album should contain an overview of your best work and the local venues that brides are most likely to be having their wedding at).

"If you are going after an upper-end clientele who tend to get married in upscale venues, don't load up your portfolio with images from events at "less than impressive" venues, no matter how good the images are. The other album should contain an entire wedding, and must reflect the quality of work that your client should expect to receive from your studio.

"Loading up an album with custom quality, retouched images, when you routinely deliver automated, un-retouched candids is 'bait and switch' and will not only come around to bite you in the end, but reflects poorly on an already tarnished image that the public has of the wedding photographer. Everybody seems to have a horror story about a 'wedding photographer,' and is quick to share them with brides-to-be.

"The problem with albums is that, basically, they all look the same! Say what you want about why your albums are different from those of studio X, but deep down inside, you know that to the client, or competitor peering through your studio window from twenty feet away, your product does not look substantially different. There are only a handful of manufacturers of albums whose products are worthy of presenting your photography in and standing behind a guarantee, and most of them do a great job of marketing to the industry, and will likely be found in most of your competitor's studios. My point is: Don't oversell the features of the album itself, but concentrate on selling the benefits of your services.

"Then, you have the presentation of the wedding album to a client for portfolio review. The typical bride will walk into her local storefront studio to be confronted by an employee who may or may not be prepared for the contact. The bride will generally be directed to a room that will have a shelf full of albums and invited to look through them. She will then be given a price list with a series of packages, from which she will begin forming opinions regarding the 'value' of wedding photography. She will most likely repeat this process

several times and begin comparison-shopping from the printed materials she has gathered. Or your bride may decide to let her fingers do the walking and go down the list in the yellow pages. Her typical question is, 'How much?' because she does not know what else to ask! And although this has the same logic as calling dress stores and asking how much their red size 4 dresses are, this is the reality of the fact that too many people in this industry focus on features instead of benefits.

"Certainly you will need some larger images to complement your albums. I recommend 16 x 20" prints mounted on triple weight art board (standard PPA competition format, and if you become active in competition, you will have a steady flow of new pieces to add/replace in your portfolio). They have great impact in the average size room, yet are small enough to carry in a case for presentations at home or in the office. Yes, your presentation should be flexible and portable enough to take it on the road, if need be.

"By the time you actually pull out the album and place it in the client's hands, the buying decision should have already been made by the client. You both clicked with them and impressed them in the first ten minutes or you lost them. When a client asks if we have any specials, we say, 'Everything we do is special. What do you have in mind? When can you come for a visit so we can

Figure 13-1

Figure 13-2

Figure 13-3

Brian & Catherine
April 28, 2000

Photo by David Rigg, www.simplythefinest.com,
© 2000 David Rigg, All Rights Reserved

Photo by David Rigg, www.simplythefinest.com,
© 2000 David Rigg, All Rights Reserved

"We have produced and use extensively a series of video and CD-ROM presentations featuring our images from different life cycles."

show you some work we have done for other clients and give you all the details regarding having a portrait created?' It is a marketing technique that both qualifies and closes the sale. Now, we don't get a lot of the 'How much is an 8 x 10"?' calls anymore. The types of people who are drawn to our marketing are the types who are intelligent enough to know that it won't be cheap.

"Having a reputation for being expensive is the best thing that can happen to you. So, in a sense, the marketing itself becomes a screening device. That gold signature in the corner of the stretched canvas, in its exquisite frame that Sandra picked out, has become a status symbol in finer homes and offices in the community. We find that sometimes the value of the investment is often exaggerated when inquired about by the owner's friends and associates. Occasionally, we will get prospects who are relieved to find out that it is 'only going to cost a few thousand dollars' for what they really want.

Figure 13-4

Figure 13-5

"We have produced and use extensively a series of video and CD-ROM presentations featuring our images from different life cycles. (See figures 13.1, 13.2, 13.3, 13.4, and 13.5 for the different life cycles.) As most of our wedding clients are out of state, the CDs and videos can be sent to a client who is making arrangements long distance. If we never see it again, we lost $5 or less and don't have the hassle of needing delivery memos signed."

(*Author's note:* David Rigg writes about the hardware and software aspects of the new technology portfolios in his book, *Creating the Profitable Image, Multi-media Marketing in the Digital Age*, e-published on a CD and available on the Web site *www.SimplytheFinest.com*.)

THE CASE

Your portfolio case should be an extension of your marketing message. Whether it is a case for a CD portfolio or a traditional print or transparency portfolio, look for a case that starts with this criterion and then has some personal distinction.

Custom cases, binders, or books manufactured specifically for your work are among the best choices. You choose size, color, and materials along with

your name or logo added to the outside and inside. If you have to shop at a local art supply store, buy the more expensive and classic leather than the cheaper vinyl or ask to look through the suppliers' catalogs for something just a little different or unique! Don't overlook the possibilities that hardware stores and luggage store outlets may offer for a choice of portfolio cases. Some of the most creative (and least expensive) options are in the most unexpected places.

THE INSIDE

For the work itself, go for quality and professionalism. It is possible that a client will assume that if your portfolio images are poorly produced or presented, the work you do for him will be, too. Poorly produced CDs, worn mats on prints, tired-looking transparency sleeves, or unmounted portfolio pieces must be taken care of immediately. Resist the temptation to just throw something into a portfolio, "just to show it." It's a poor excuse for an incomplete presentation.

Since most clients still want to see a traditional portfolio, you need to decide whether to show your work as reflective art or as transparency. Either one can be laminated or mounted, but they don't mix well. It's really a personal decision based on your budget and comfort level. Also, consider using the one your prospective clients are most comfortable and familiar with. If you don't know what they prefer, ask them! If you choose reflective art, make color or black and white prints of your work, and laminate or mount them. If you choose transparencies, they will also need to be laminated or mounted. It is also a good idea to have your name or logo on each lamination or mat board.

What size should your portfolio be? Most portfolios today are in the range of 8 x 10" to 11 x 14". This is the size of the mat board or lamination. All of your portfolio pieces should be the same size and then, inside this dimension, you can mount any size image!

How many pieces should you show? Remember: A complete body of work is *not* a portfolio. The entire collection of pieces could be dozens or even hundreds of images. Any given portfolio should be a selection of ten to fifteen boards or laminations, depending on the particular client. Because each board or lamination could show two or more images, this keeps the portfolio quantity manageable, while not severely limiting the number of images you show.

If you have to make even a glimmer of an excuse for an image in order to show it, then *don't show it!* Yes, it will take some effort to make the time to have the proper matting materials on hand, to get that artwork to the lab for the copy transparency, to properly format and label those CD-ROMs, and to find the money and time to do all this. It is worth it. It is your career, your business on the line.

Chapter 14

KEEP CLIENTS COMING BACK

W HEN YOU GET A CALL FOR THAT FIRST JOB WITH A CLIENT, THERE IS A tendency to rush through the business practices procedures. The catastrophic fear you have is that the clients will change their mind and give the work to someone else. Don't let your fears over-rule good business sense. From the way you handle the first job to the first time you have a project or price conflict sets the tone and the code of behavior for the relationship.

Also, in today's marketplace, many photographers complain about the decrease in repeat business and the decline of client "loyalty." Many clients hop from photographer to photographer looking for the best price or the latest trend.

To keep your clients coming back and paying your price, you need to become more aware of the courtship and bond in the photographer/client relationship. These ideas won't work with every client, but then what are your choices? You can try some of these techniques and see how they work or just give up and let your clients leave. Not much of a choice!

Use the suggestions below to:
- Increase your awareness of what clients really want
- Give yourself a competitive edge
- Provide copy ideas for ad headlines and promo text
- Add "editorial content" to your marketing materials and Web site
- Stand out in the flood of promotional materials clients receive
- Make yourself irresistible to clients
- Add value to their work with you
- Help clients decide that you are the one!

Here are some tips for developing and maintaining a strong, healthy and profitable relationship with your clients.

DEMONSTRATE TECHNICAL ABILITY

Your portfolio and promotional materials will do some of this, but never assume anything! Be sure to distinguish between knowledge and skill. Knowledge means you have learned a technique and skill means you have practiced it. Always be honest. Any deception here as to your level of skill will come back to haunt you in the future. For example, perhaps you know how to photograph the facility for an annual report, but have never actually done so.

The distinction is often important to clients. They will have different expectations of you depending on your accurate reporting of your knowledge and skills.

SHOW YOUR CREATIVITY

Beyond technical ability (the determination that you can do a task correctly), the photography client will look at your level of creativity or personal style. Be sure you find out the culture or personality of the client. This perspective could vary from very conservative to very unstructured and will dictate the level of personal creativity the client will look for in your work. You can actually be "too creative" for some clients. For example, the corporate communications client may love your personal work, but can't figure out how to sell your unique or unusual style to the board of directors. The answer is to show your "straight" work to those clients who get it and find different clients for your highly creative work—two different marketing messages!

BE A PROFESSIONAL

Most clients must answer to a higher power, and professionalism means that you will be less likely to make them sorry they hired you! The best evidence to the client that you are a professional is your membership in a profes-

sional photography association. There are many other ways a client can judge if you are a professional before you ever get a chance to work together. For example, how you answer the phone, present your portfolio, dress for the interview, follow up after you've met, market your work to them. Take every opportunity to give strong evidence of professionalism. In the working relationship, consumer and commercial clients may measure your professionalism differently but all will agree that a professional delivers value.

David G. Rigg says, "All clients want value for their hard-earned dollars. I have many clients who are multimillionaires and they are some of the hardest-working people I have ever met, and they too want value for their dollars. They just happen to have more dollars and can afford to pay cash for things that you and I might have to finance. This concept of value translates into the fact that clients don't want to waste time or money. What they are really looking for is the comfort of knowing that you will get the job done to their satisfaction with a minimum of effort and disruption to their already hectic lives. Some of the high school seniors that we work with have their calendars so crammed full that you wonder when they have time to be teenagers and enjoy life."

DISCUSS PREVIOUS EXPERIENCE

Not much you can do here if you don't have the experience but get as close as you can. Even if the experience you have is only similar to products or services of theirs, this gives clients the impression that you can meet their needs as well. Bluntly put, it means that you have learned the ropes at some other client's time and expense!

If you don't have exactly the right product or industry experience, get busy with self-assignments (chapter 13). For example, you can show financial services images to health-care clients, since they are both consumer-oriented services. Take the time to build your portfolio in the areas where you want to approach new clients. Also, learn as much as possible about the client before the interview and make sure you have the right work to show. Ultimately, being able to demonstrate experience with the company's product or service will make it easier for the client to work with you. Help him hire you!

MEET THE CLIENT'S REAL NEEDS

Be sure to find out what specific problem this photography project is supposed to solve. The more accurate a statement you obtain from the client about the objective, the better the chance you have to meet it *and* the more accurate the budget. Don't take anything at face value. It is not at all unusual for a communications department to be told to produce a brochure for the president without knowing what the brochure is for! Help your client be a "star" by shooting the projects to meet a specific goal. Be sure and listen to what the client

really needs, not just what she says she wants.

Julie Diebolt Price says, "To keep clients, I think that I must be more cautious in taking assignments that are not clearly thought out by everyone involved. It's up to me to find out *exactly* what the client is looking for, then give it to them. And in order to give them what they want, I must communicate the requirements, even if it's not what they want to hear. One has to be strong and specific. In dealing with problem clients, you must maintain a professional detachment and find out what the real issues are. Listen. Ask the client how they want the issue resolved—many times it may be less than what you would have offered. Other times, they just don't want to be satisfied. In that case, refer back to the signed contract where everything is spelled out in writing. Make concessions where it makes sense for good client relations, cut your losses where there is no hope of an amicable resolution."

MAKE THEM FEEL SAFE

As a rule, a photography client will look for, and work with, photographers on a repeat basis whom they feel safe working with. Your challenge is to help them feel safe enough to keep them coming back for more!

The one exception may come up when you are selling a personal style. When a particularly innovative client is looking for a unique style to use on a specific project, safety becomes less of an issue and style is a greater concern.

But most clients are looking for relationships they can count on and depend on; they want to know that they are making the right decision to work with you.

Today's competitive marketplaces justify a closer look at how clients and photographers look at their relationships and make decisions. The more you study and learn about the relationship between your prospective photography client and your business, the better chance you have of getting the job and turning that job into a client.

Chapter 15

PACKAGING YOUR COST PROPOSALS

ALL PHOTOGRAPHERS RUN INTO THE SAME WALL-PRICING. THERE IS SOMETHING about that much-anticipated yet dreaded question, "What do you charge?" that causes many photographers to flinch in dismay. There are probably a dozen psychological reasons for this feeling of vulnerability. Rather than take on the feelings behind pricing your work successfully, let's look at specific actions and behaviors to improve your pricing success.

THE BIG QUESTION

The first step to getting paid what you're worth is to quote a price both you and the client can live with—and profit by! This process begins when a prospective client or customer asks the big question, "What do you charge?" To start with, he is asking the wrong question and must be stopped and corrected.

There are two questions the client could be asking. First, he might really want to know, "What does it cost to shoot my job?" In this case, you go on to step one and get a complete job description to give him a cost for the photos or the use of the photos.

Second, he doesn't have a job at the moment, but would like to know what it would cost to work with you if he had one! With the increase of price consciousness among clients, this is a great concern. It is also a very difficult question to answer. How do you quote a job when you don't know what the client wants yet? You have to understand that all he is really asking for is some way to measure you against other photographers. Day rate can't answer that question for several reasons.

1- Day rate is not an accurate measure of photography cost, as it does not include expenses.

2- Day rate does not transfer usage rights, the real "sale" in selling photography.

3- Day rate implies employment, and you know the client does not want to employ you.

Your best bet is to prepare some simple measuring devices to use when clients want a price, but don't have a job to quote. Try using a price range or asking them to describe a typical job, or even pricing something they like out of your portfolio—anything to give them your "measure."

For the best reference guide on copyright, usage, and pricing guidelines for both assignment and stock photography, see *Pricing Photography* 2nd edition by Michel Heron and David MacTavish (Allworth Press). For wedding and portrait pricing, check with your local photography associations (another advantage of membership!)

STEP ONE: GET THE COMPLETE PROJECT DESCRIPTION

When the client has a specific job request, it is very important to get a complete description of what he needs before you present your cost proposal. Ask your own version of these five questions:

1- What do they specifically need?

Describe the number of views, how many people or products (or both) are in each view and be sure to include variations! Get exact background, set, props, and surfaces as well as film and print requirements. Also, be sure to find out how it will be printed (for commercial jobs), as that will dictate your expenses on scanning and delivery media.

2- When do they need it delivered?

Don't forget to include any possible rush charges for a faster than normal delivery. Your best bet is to ask information-gathering questions designed to help the client feel more comfortable with your ability to come through for him. Instead of "When do you want this job done?" (much too subjective an issue), ask for more objective and measurable

information, such as "When will the annual report be mailed? How many people need to approve it, and how long will that take?" By breaking the deadline into a series of checkpoints on a timeline, both you and your client will feel more in control of the process.

Always be able to help your client motivate others in the approval process by giving them printed timeline material. Be a partner with your client. It is the two of you against all the other forces that can delay a job.

3- Who will see it and what will they do with it?

For commercial jobs that sell usage rights, some clients can tell you exactly the rights they want to buy. But when your client isn't familiar with copyright and usage pricing, try the question above. This question will determine whether your photography will be a simple booth graphic (it will be seen at our trade show) or used for a national advertising campaign (it will be seen in a magazine ad!).

4- What is the budget?

What were they planning to spend on the photography? Either question is good, and though clients won't always tell you, at least they know that you are concerned. You'll get the information in a later contact with them; so don't worry if they won't give you the answer right off the bat.

5- Who else is giving them a cost proposal?

This question will often tell you the answer to the "budget" question! Again, your client may not want to give you this information, but at least you'll know whether the job is being put out for bids or if you are the only one in line for it.

The Approvals

This is a touchy subject between any client and her photographer. Sometimes, both are caught in nightmarish scenarios where everyone responsible loves your ideas and then someone with a higher authority shoots them down. Not only does this make your photography client look bad, but you could also lose her as a client! Do the most you can to protect yourself and your client—be a team. Find out how many people need to "approve" your work. Is this done by e-mail or courier delivery? Will there be consultations with you during the job or will your client make the approval presentations for you? Again, how long will all this take?

Also, be sure to distinguish between subjective and objective approvals. Subjective is someone's opinion and should be given only to the highest level of authority; for instance, is this the exact blue color background they had in mind? An objective approval is a measurable determination of accuracy—is this the correct number of photos?

The Payment

Always work out all the details of deposits and payments at the beginning of a job. In consumer photography, wedding and portrait clients usually pay a substantial amount upfront to secure the photographer. Payment for commercial photographers is often related to the type and size of the client. The larger the company, the further away your contact is from the person writing the checks. When your commercial client does not know how you should proceed on the issue, ask if you can talk with his accounts payable department. He will probably appreciate one less thing he has to do, and the accounting department will be happy to tell you what to do to get paid in a timely manner!

Estimating Software

At this point, you may want to get some professional help in putting together your estimate before calling the client back. You can now buy different computer software programs that will assist you with the big question, "What do you charge?" For example, FotoQuote is a software program for pricing and selling stock photos (*www.FotoQuote.com*). Once you get into the program, you'll be prompted to choose from various usages in categories and subcategories before the program suggests a calculated fee. In addition, you get a professional pricing "coach" that offers tips you can print and keep on hand.

STEP TWO: BE PREPARED TO NEGOTIATE BEFORE YOU HAVE TO

Before the final step of presenting a nicely packaged cost proposal, you may want to discuss and negotiate your price. What happens when the client wants to pay less? Answer: You walk away or you negotiate. I support you if you walk away. I can teach you how to negotiate. I do not accept the option of dropping your price without negotiating some consideration in the project description. Photography is not a product pulled down off a shelf. Never drop your price for a specified job description without some consideration made—by you or the client. Not only is it unprofessional, it plants doubt in your client's mind of the value of your work and you'll never get paid what you're really worth! In addition, you'll probably lose money (and your self-esteem) on the job and that client will try to get the next photographer to drop his price without a reason. You can always walk away if you are not willing to negotiate or the client simply can't come close enough in her budget to what it really costs to do the photography work.

Before you take the jump to negotiate the price, find out what is really going on with the client. My favorite situation is when the client tells you, "I can get it for half price from someone else." To keep the conversation rolling, I usually ask a one-word question in response: "How?" The client stops and thinks.

What I am really asking is, "How can it be done for less money?" You tell the client that your price for photography is a fair, normal, and industry-average price. Then, you ask, "How can it possibly be done for less money?" Ask him, "What will you get less of and do you want to know now or be surprised later?"

If the client's price is close enough for you to think of doing the job, look at considering some negotiation. Do take any and all negotiating seminars and classes you can find but you must learn at least this one technique. It is a simple concept: For the client to pay less, *the client will get less* of some piece of the project you both agree to or *you will get more* of some piece of the project.

Simply put, when the client names a price lower than what is acceptable, your answer is any variation of "Let's take a look at how it can be done for that price." Then you look at your two lists. One is a list of the considerations clients can make to lower the price. For example, they can get less usage rights or fewer consultations.

If you need to, go to your second list of the considerations you can get more of to lower the price. To do the work for less money, you can get more time or better payment terms. Work on this now. The negotiation is easier and faster when you have lots of items to choose from on your two lists. The bottom line is this: Do not accept less money for the same work. You will damage your chance at a profitable relationship with clients. You will give your work away. Don't do it. Learn successful negotiating techniques to get the best return on your investment in your business!

STEP THREE: TALK ABOUT PRICE

Don't quote prices off the top of your head! Plan on calling clients back when you don't know them well enough or don't know if you have the job for certain. Always ask when would be the best time to call them back. Often, clients have much more time than you feel they do and you do need the extra time! This will give you the chance to do an accurate cost estimate and it shows your client respect for her request of your photography services. When you call her back, you will use a script to get some feedback on that mysterious budget figure she probably didn't tell you about in step one. This feedback will help you determine exactly how much work you have to put into the written cost proposal (step four) she will receive from you.

You should prepare this verbal presentation script in advance so that you can handle any response. For example, when you ask, "From what you described, it will cost $5,000. How does that fit your budget?" clients will respond positively or negatively. If they respond positively, then you go to the next step. If they respond negatively, then you go back to step two and, before you put anything in writing, negotiate considerations until you and your client agree that the price is now "in their ballpark."

STEP FOUR: PACKAGE YOUR PRICE TO GET THE JOB

Now that you and your client have a price you both agree on, you'll find that a better-looking proposal of the cost can be the difference between getting the photography job or not. Whether you are doing commercial, industrial, portrait, or wedding photography, a meticulous presentation of your price better demonstrates your professionalism, expertise and abilities. This will help the client or customer decide to hire you instead of a competitor.

A good cost proposal can help you get the work, because it explains to clients the value they will get for the price they will pay! To show you the best way to present your price, we will "walk through" a typical photography cost proposal.

The Contract

The contract information, more commonly called the "estimate confirmation," should be printed on your own letterhead to look as professional as possible. Use the industry standard forms with customary contract law for photographers to protect you and your client.

Please be sure to get the forms from your professional photography associations. You can also find these forms in the book, *Business and Legal Forms for Photographers* by Tad Crawford (Allworth Press). Your professional associations are also the best place to look for the support you need to make sure you are profitable with your pricing. Successful pricing starts with good business practices and organizations such as PPA and ASMP have been established to inform and educate photographers on business issues. If you are not participating in your professional peer association, start today. If you are not a member, join now for relationships you will need later!

It is very important to get the correct name of the person with the authority to hire you and pay you. Does your client have the responsibility to find you, but need further approval to hire you.

When you are dealing with an advertising agency or third party of any kind, be sure to get its client and project names. Ad agencies get lots of photography estimate confirmation forms, and you want yours properly considered by the right people!

Since any alteration in the project could cause an increase in expenses, getting a detailed job description can avoid the problem of going back to the clients for more money to produce what they wanted in the first place. You really should get any fee or expense increases approved by the client during the job.

The Fees

Photography fees should include a complete statement of the use of the photos. Will these photos be used just for display and exhibition or for repro-

duction in an ad, brochure, or Web site? Just because your wedding, portrait, or fine art client usually buys only the prints (real property use) does not mean he is not planning some reproduction use (intellectual property use). Ask clients what their plans are for the image use and reuse. Plan ahead!

Also, to maximize profitability, find out which budgets can be dedicated to your part of the job. Often, a fee is set aside for photography but that is just one line item on a project budget. Whether it is a wedding or a catalog shoot, technology today allows you to do more of the imaging work. These are often other line items named in that project budget that really should be rededicated to the "photography" fee. Check on preproduction, research, any and all retouching, postproduction, and prepress, to name a few. The money is there to pay you for the extra work; it just may not be called "photography fee."

The Expenses

Photography expenses can only be estimated, and your form should state that the client agrees to pay actual expenses. Industry standard variation of 10 percent above or below the estimate is customary to expect and should be stated on the front of the contract, but I would still recommend that you get an estimate amendment if the price goes up. No one likes surprises.

State clearly what your price includes (such as the size and number of prints) so that your clients know exactly what they are getting. Don't let any expenses come out of your fee. Calculate the delivery charges, special research needed, proofs—any possible expenses for the photography assignment. Check again on the industry standard forms for a complete list of "billable" expenses.

The client's approval must be obtained if final costs will exceed your original estimate by more than 10 percent, but I think it is still a good idea to get a signature on any cost overage you may be expecting. The standard contracts state that clients will pay for any changes or revisions they make to the original job description. So, the more detailed the description, the less you risk absorbing any of these extra expenses!

The Payment Terms

Deposits or advances should be discussed. A deposit is a percentage of the total cost (from 30 percent to 50 percent) that the client pays to confirm the assignment and is more common in wedding and portrait photography. Commercial photographers should try to get any amount of deposit; you are not a bank, you are a photographer.

An advance is the prepayment for the expenses of costly preproduction or travel. Your invoice should be paid when the photos are delivered or sent to your client's accounts payable department for payment "net receipt." This

should get you paid within thirty days. A late payment charge (usually around $2\frac{1}{2}$ percent) should be quoted on all jobs. It is customary for the client to pay any legal fees if needed to collect money.

Now comes the fun part. Remember, unless you know you already have the job, you may need to give the client more than this estimate confirmation (contract) to help her decide to hire you. More important, the person you call the "client" probably has to get this approved and needs something to show and help get you the job. After all, the estimate confirmation just tells her what it would cost to hire you, but not why it is a good idea!

The Cover Letter

A good cover letter warms up an otherwise cold-looking contract. It will help your client (and even the decision-making committee or higher-ups) decide to hire you. Here is an example of a cost proposal cover letter.

> Dear Robert,
>
> It was a pleasure talking with you yesterday! As we discussed, enclosed is the estimate confirmation on the portrait photography you need for your annual report.
>
> In addition, we have enclosed the special black-and-white samples you requested from our Web site. You'll find our style of portrait photography will be exactly what you need. Because we have been established portrait photographers for over twelve years, you will receive the experience and expertise this project requires.
>
> Also, when you are ready to proceed with the photography for your upcoming trade show, we will work with you to develop the "new look" you need for your company.
>
> I'll call next week to find out when you will be making a final decision on this job. We are looking forward to working with you!
>
> Sincerely,
>
> Maria Piscopo
>
> P.S. Please let me know if you have any questions or need any additional samples of my work.

Add Samples of Your Work

Include samples of the work you will be doing. In this case, the client is interested in a subject expertise, portrait photography, and in a particular style, black and white.

Never assume that the client will remember the work he saw in your portfolio or that he pulled your promotional materials from his files. Count on hav-

ing to visually reestablish your photography credentials. This will help you get the job because you have shown you can do the work requested. Also, samples will help your client get you the job when he has to present your cost proposal for decision by a committee that has never seen your portfolio!

Add Credibility

In addition to your contract and samples, you can add credibility by submitting proof of your capabilities. This may be the pivotal factor in helping the client decide to hire you. More likely, your client may need these items to certify your reliability so he can sell you to his own committee of "decision makers."

Examples of proof of your credibility include testimonial letters from satisfied clients, awards you have won, exhibits of your photography, a list of clients, client references and professional organizations you belong to. Anything you can do that will give you additional trustworthiness and help the client make the right decision—to hire you!

Chapter 16

THE ETHICS OF GOOD BUSINESS

A s in any other business, there will be ethical considerations in photography that confront you on a daily basis. You can make a difference by being prepared. You prepare by thinking through potential situations that could arise and having some idea about how you would handle the situation. One of the advantages of peer associations (examined in chapter 7) is that you can meet and network online or in person with other pros and compare notes.

First, what is ethics? Ethics is the development of characteristics that will help you make good choices of behavior. The characteristics that are the foundation of ethical behavior include: integrity, honesty, trustworthiness, truthfulness, commitment, awareness of or sensitivity to the situation, responsibility, fairness, and a sense of compassion. Being ethical for a photographer does not mean you are weak or nonassertive! Ethical behavior is the basis of successful and profitable business practices.

Why is this important to you? Because your clients and peers will expect you to maintain as normal your good business practices, but they will never let you forget the one time you behaved dishonorably. Because you will find that it is practical. Clients who don't feel as if they were treated fairly or honestly

won't come back, and it is very expensive to constantly be looking for new clients. Finally, you will feel good when you do the right thing.

Ethics do not always involve big decisions, and you are probably making good day-to-day ethical decisions without a second thought. Your behavior every day forms a code of conduct. Often, it is inspired and directed by the feeling of wanting "to do the right thing." Here are some examples of photography situations you may encounter that could test your ethical behaviors.

- Delivering on all contracts, even verbal, whether it is with a client or an assistant. Always do what you say you are going to do.
- Fairly billing expenses for jobs, getting the markup you need to make a profit while not taking advantage of your client.
- Maintaining confidentiality in the client/photographer relationship. Your client should be able to trust you to shoot proprietary or restricted products and not have any "leaks" outside your studio.
- Making honest and accurate claims in your advertising and marketing.
- Dealing fairly in your agency or rep relationships and abiding by the contracts you both agreed to.
- Being honest in your creativity; if you are inspired by someone else's work, you adapt it, not adopt it!

As a rule, you know that you are facing a decision based on ethical behavior when you can identify the following three factors:

1- Your personal happiness would be achieved at the expense of fairness or honest treatment of another person.

2- Other people who will be affected by your decision are not considered or consulted and their voices are not heard.

3- The long-term gain of your decision is taken as a more important consideration than the immediate gain or benefit. In other words, doing the right thing may not yield its benefit right away.

How do you know you are on ethically "thin ice" when you are facing any decision? The best test is to watch for rationalizations you verbalize (or think to yourself) that you believe will allow you to proceed with an ethically poor behavior. Here are some common rationalizations:

- I'm just fighting fire with fire.
- It's not illegal, is it?
- Everyone is doing it.
- It's just how you play the game.
- No one is really going to get hurt.
- I'll do whatever it takes to get the client.
- I'll only be as ethical as my competition.

There are the bigger ethical and legal issues in the photography industry that the professional associations have confronted. The Joint Ethics Committee (they are not in service as of this publication) compiled and published a Code of Fair Practice that has been in use since 1948. A few organizations have kept the Code updated, as needed, and, since it covers business practices between clients and creative professionals, it applies to you as a photographer. The Graphic Artists Guild offers an excellent explanation of all of these articles in its latest book on the subject, *Graphic Artists Guild Handbook, Pricing & Ethical Guidelines, 10th edition*. For more information visit *www.gag.org*.

Every photographer should decide on how to do business on his or her own; these guidelines can only give you the "industry" boundaries and standards of professional conduct. Anything can be modified by your written contracts once you know the Code!

THE CODE OF FAIR PRACTICE

ARTICLE 1 Negotiations between an artist or the artist's representative and a client shall be conducted only through an authorized buyer.

ARTICLE 2 Orders or agreements between an artist or the artist's representative and buyer should be in writing and shall include the specific rights which are being transferred, the specific fee arrangement agreed to by the parties, delivery date, and a summarized description of the work.

ARTICLE 3 All changes or additions not due to the fault of the artist or artist's representative should be billed to the buyer as an additional and separate charge.

ARTICLE 4 There should be no charges to the buyer for revisions or retakes made necessary by errors on the part of the artist or the artist's representative.

ARTICLE 5 If work commissioned by a buyer is postponed or canceled, a "kill fee" should be negotiated based on time allotted, effort expended, and expenses incurred. In addition, other lost work shall be considered.

ARTICLE 6 Completed work shall be promptly paid for in full and the artwork shall be returned promptly to the artist. Payment due the artist shall not be contingent upon third-party approval or payment.

ARTICLE 7 Alterations shall not be made without consulting the artist. Where alterations or retakes are necessary, the artist shall be given the opportunity of making such changes.

ARTICLE 8 The artist shall notify the buyer of any anticipated delay in delivery. Should the artist fail to keep the contract through unreasonable delay or nonconformance with agreed specifications, it will be considered a breach of contract by the artist. Should the agreed timetable be delayed due to the buyer's

failure, the artist should endeavor to adhere as closely as possible to the original schedule as other commitments permit.

ARTICLE **9 [NEW]** Whenever practical, the buyer of artwork shall provide the artist with samples of the reproduced artwork for self-promotion purposes.

ARTICLE **10** There shall be no undisclosed rebates, discounts, gifts, or bonuses requested by or given to buyers by the artist or representative.

ARTICLE **11** Artwork and copyright ownership are vested in the hands of the artist unless agreed to in writing. No works shall be duplicated, archived, or scanned without the artist's prior authorization.

ARTICLE **12** Original artwork, and any material object used to store a computer file containing original artwork, remains the property of the artist unless it is specifically purchased. It is distinct from the purchase of any reproduction rights. Artwork ownership, copyright ownership, and ownership and rights transferred after January 1, 1978 are to be in compliance with the Federal Copyright Revision Act of 1976. All transactions shall be in writing.

ARTICLE **13** In case of copyright transfers, only specified rights are transferred. All unspecified rights remain vested with the artist. All transactions shall be in writing.

ARTICLE **14** Commissioned artwork is not to be considered as "work for hire" unless agreed to in writing before work begins.

ARTICLE **15** When the price of work is based on limited use and later such work is used more extensively, the artist shall receive additional payment.

ARTICLE **16** Art or photography should not be copied for any use, including client presentation or "comping" without the artist's prior authorization. If exploratory work, comprehensives, or preliminary photographs from an assignment are subsequently chosen for reproduction, the artist's permission shall be secured and the artist shall receive fair additional payment.

ARTICLE **17** If exploratory work, comprehensives, or photographs are bought from an artist with the intention or possibility that another artist will be assigned to do the finished work, this shall be in writing at the time of placing the order.

ARTICLE **18 [NEW]** Electronic rights are separate from traditional media and shall be separately negotiated. In the absence of a total copyright transfer or a work-for-hire agreement, the right to reproduce artwork in media not yet discovered is subject to negotiation.

ARTICLE **19** All published illustrations and photographs should be accompanied by a line of text crediting the artist by name, unless otherwise agreed to in writing.

ARTICLE **20** The right of an illustrator to sign work and to have the signature appear in all reproductions should remain intact.

ARTICLE 21 There shall be no plagiarism of any artwork.

ARTICLE 22 If an artist is specifically requested to produce any artwork during unreasonable working hours, fair additional remuneration shall be paid.

ARTICLE 23 All artwork or photography submitted as samples to a buyer should bear the name of the artist or artists responsible for the work. An artist shall not claim authorship of another's work.

ARTICLE 24 All companies that receive artist portfolios, samples, etc., shall be responsible for the return of the portfolio to the artist in the same condition as received.

ARTICLE 25 An artist entering into an agreement with a representative for exclusive representation shall not accept an order from nor permit work to be shown by any other representative. Any agreement, which is not intended to be exclusive, should set forth the exact restrictions agreed upon between the parties.

ARTICLE 26 Severance of an association between artist and representative should be agreed to in writing. The agreement should take into consideration the length of time the parties have worked together as well as the representative's financial contribution to any ongoing advertising or promotion. No representative should continue to show an artist's samples after the termination of an association.

ARTICLE 27 Examples of an artist's work furnished to a representative or submitted to a prospective buyer shall remain the property of the artist, should not be duplicated without the artist's authorization and shall be returned promptly to the artist in good condition.

ARTICLE 28 [*Original Article 28 has been deleted and replaced by Article 29*] Interpretation of the Code for the purposes of arbitration shall be in the hands of the Joint Ethics Committee or other body designated to resolve the dispute, and is subject to changes and additions at the discretion of the parent organizations through their appointed representatives on the Committee. Arbitration by the Joint Ethics Committee or other designated body shall be binding among the parties, and decisions may be entered for judgment and execution.

ARTICLE 29 Work on speculation; Contests: Artists and designers who accept speculative assignments (whether directly from a client or by entering a contest or competition) risk losing anticipated fees, expenses, and the potential opportunity to pursue other, rewarding assignments. Each artist shall decide individually whether to enter art contests or design competitions, provide free services, work on speculation, or work on a contingency basis.

Chapter 17

PHOTO REPRESENTATIVES AND OTHER AGENTS

WHAT IS A PHOTO REPRESENTATIVE AND WHAT DO THEY DO?

Art/photo representatives own their own businesses. They usually represent a group of noncompeting commercial illustrators and photographers ("talents"), all of whom own their own business. The relationship is that of an independent contractor, not an employee and employer. The photographer and the rep work together to promote the photographer to potential new clients and the photographer pays 25 percent to 35 percent commission on the fees of jobs in the rep's territory. Photographers often maintain their own clients as "house" accounts not subject to the rep's commission. Many photographers, however, want the rep to work with all of their clients and give all or part of their house accounts, with commissions, to the rep.

Normally, the photographer's general business and office management are not part of a photo rep's job responsibilities. Reps do the marketing work to build your business in three important ways.

1- They find new clients for the kind of assignments you want to do.

2- They negotiate the best pricing and terms with those clients.

3- They keep those clients coming back again and again.

HOW REPS WORK

For each talent they represent, reps usually work a geographic territory looking for a specific kind of photography assignment. Geographic territory can be limited to a city, a region, a country, or regions of the world (North America, Europe, the Pacific Rim). Many photographers have different reps in each of the major advertising markets around the world, divided into these geographic territories.

Though most photographers can do any kind of assignment, to avoid conflict with their other talents, a rep will sell each one as a "specialist." For example, a rep might have a people photographer, a food photographer, a product photographer, and so on. A rep works most successfully and profitably when she works in one of the commercial photography markets that hire many different types of photography (such as an ad agency). In other words, to bring in 100 photo assignments from 10 or 20 clients makes a rep more profitable than when she has to work 100 different clients! Time (again) is money.

Because of this, you'll find most reps in the major metropolitan areas where they have a large pool of advertising agency clients. Because an ad agency has many different kinds of clients and photography needs, advertising executives often work with a rep who has a variety of photographers to match those needs.

In addition to the job title of art/photo rep, there are other types of "agents" for photographers who do not compete with the art/photo rep looking for commercial assignment work. Fine art reps have a business structure very similar to the art/photo rep, but their clients are usually in the corporate fine art market. Galleries also work with fine art photography on a commission basis and work with all types of fine art sales. Stock photo agencies represent a photographer's photo library of images for all types of usage sales.

When photographers or photo studios want a rep to give their business undivided attention, they will have to employ someone to act as their rep exclusively. These "in-house" reps are employees of the photographers. Because they are employees, they usually do not represent any other photographers or talents and often include office or studio management in their job responsibilities. They are paid on a salary or salary-plus-commission basis, and most often have the job title of "marketing coordinator." (See chapter 18.)

HOW DO YOU KNOW IF YOU ARE READY FOR A REP?

Here are some clues to determine if you are ready to look for an art/ photo rep:

- You're probably ready for a rep if you are too busy with photography assignments and self-assignments to make the personal contacts to find new clients and keep the ones you have.

- You're ready for a rep if you have enough repeat business from a stable client base of "house accounts" that you can spend the money reps require for additional promotional materials.

- You are ready for a rep if you have a strong style or specialty that a rep can sell to advertising agency clients.

- You are ready if you consider yourself first as a business then as a photographer. Reps like to work with photographers who appreciate the "business side" of their work. You are, after all, in business to make money!

- You are ready for a successful rep/photographer relationship if you are open to new ways and new ideas to promote your business and need a rep's time and expertise to help you.

- You are ready if you have a portfolio ready to go out the door and it represents the kind of work that you want to do more of. Working on commission, reps can't stand by without work to go and show.

- You're ready if you have the budget for the promotion pieces and marketing plan to support the rep! *You will not spend less money* on marketing when you have a rep. An average budget for self-promotion is 10 percent of your projected gross sales.

- You are ready if you are willing to spend the time to assist the rep in selling your work. *You will not spend less time* on your marketing by having a rep. You just won't do the same things—for example, instead of calling the clients, you will be creating new portfolio pieces for the rep to show them!

HOW DO YOU FIND A REP?

Finding a rep is very similar to the search for clients. You must research the reps, present your portfolio and do the regular follow-up required to build a relationship. Reps are a lot like clients in that they may already have someone who does the kind of photography you want to do and good research and consistent follow-up are the only ways to break through this barrier to working together.

Knowing whom the rep already works with allows you to approach the rep in a way that will make the very best impression. Perhaps you find out the rep does not have a people photographer and may need one. Your approach will be to help the rep by being his people photographer so that they can offer clients a better, more complete service.

Perhaps the rep already has a people photographer—you could offer to be available as a "back-up," working on a job-by-job basis. There are many possibilities. Once you know that you are ready for a rep, the next important thing to look at is what the rep's needs are and how you can meet them.

Where do you find information about reps? First, most of the creative sourcebooks list the names and addresses of photography reps. Some, like *The Workbook Directory* (*www.workbook.com*), list the talents each rep represents and her specialties. You can buy a mailing list or directory of reps who belong to the professional association, SPAR, the Society of Photographers and Artists Reps (New York). SPAR also has a newsletter where you can buy an ad to find a rep for your business. In addition, Writer's Digest Books (Cincinnati) publishes a book that lists reps, how they work and what type of photographers they are looking for. *The Photographer's Market 2001* is updated each year so be sure to get the most current year when you buy the book!

THE REP/PHOTOGRAPHER RELATIONSHIP

Many problems in the rep/photographer relationship can be traced to new reps just getting into the business or photographers unaware of the formula for a successful rep business.

Here are four different factors that can lead to relationship problems:

1- What doesn't work very well are reps who don't realize they are in business for themselves. It is a struggle for a rep to survive on the new clients of just one photographer without getting a percentage of house accounts. It is not profitable to represent such a diverse and disparate group of talents that it takes 100 clients to get 100 jobs or to rep photographers who have additional reps in every major city. It is impossible when the photographer "borrows back" the portfolio and tells the rep to go out and get work and *then* the photographer will do a promo piece. When any of these situations exist, you have an unhappy photographer saying, "reps don't work." Well, they didn't have a chance in the first place!

2- Another factor in the unhappy relationship of a photographer and rep is the result of the major client shift from selling photography to marketing photography. When reps could rely on getting enough appointments with clients and developing enough personal relationships with art directors to keep their multiple talents busy, everyone was happy. A rep's job has always been to sell, to go one-on-one with the client. Though this is still true today, many photographers find that they need to use more "nonpersonal" tools of marketing, such as advertising, direct mail, publicity, and Web sites to get clients. Though personal relationships are still important, the reality is that personal appointments are much more difficult to get. How do you compensate a rep working on commission for writing a press release or planning an ad or creating a Web site? These are all important tasks but they take precious time away from a rep's time-consuming job of one-on-one selling and are usually expected by the photographer without compensation to the rep.

3- As the marketplace for photography becomes global with Internet marketing, more photographers question the wisdom of committing to a single rep with a worldwide exclusive contract. With the technology today, photographers can work with a client in another country as simply as they can work with a client down the street. While a rep needs and wants this kind of very broad geographic territory of clients, photographers are less and less happy about giving them an exclusive to it. Someone does need to manage this broader scope of clients; whether it is a rep or a marketing coordinator will be the deciding question for the photographer.

4- Finally, as more clients shift to new technology marketing tools, less money is spent on traditional print advertising. As more clients make this shift and advertising agencies give out fewer jobs, the rep has to work more clients to bring in the same number of jobs. Suddenly, that art director giving the rep one or two jobs a week falls back to one or two jobs a month, or merges with another agency, or disappears altogether. The other problem with this shift is the effect it has on the way clients hire a photographer. With a print ad, a rep can be presented a (usually pretty tight) comp and go right to the pricing stage. With newer technology, the photography is often much less defined and the client needs to have a much closer, consulting relationship with the photographer to get what he wants.

It is unproductive to point out a problem without some possible solutions. Here are two possibilities for the "new" rep/photographer relationship.

Reinvent the Relationship

Reps can build their own businesses with some adjustments, such as a broader client base and a greater variety of talents. Either way, no photographer is going to get the unlimited time and attention of a rep unless the photographer agrees to be financially more supportive of the rep. Some photographers are giving the rep a percentage of gross sales or making the rep a partner or paying a monthly marketing "maintenance" fee for all that nonclient contact work such as writing those press releases!

Hire Someone In-House

An entirely new job has come out of all of these changes. It is a marketing coordinator (see chapter 18). A photography studio (especially with multiple shooters) is the most likely to need this type of job position. The job description covers everything from office management, database management, writing press releases, and researching to develop new clients. Compensation can be salary, salary plus commission, or a partnership agreement. Though I have seen this concept work very successfully, no one has quite decided what to call it. Some job title options are marketing coordinator, sales manager, producer, or

partner. The title of photo rep should not be used for an in-house marketing person because it implies that she represents multiple talents when she does not.

Whatever option is selected, there is no doubt that reps and photographers have to re-examine their own reasons for being in business and start exploring their options.

Chapter 18

HIRING AND WORKING WITH MARKETING COORDINATORS

TRADITIONALLY, THE PHOTOGRAPHER HAS WORN ALL THE HATS IN THE BUSINESS. But just because you are a sole proprietor does not mean you have to work alone! Today's photography business owner may need to employ a part- (or even full-) time person to help with the daily chores of marketing and management. This person is not a rep. You could have an independent photography representative and still hire a marketing coordinator. The rep will have his own business and other talent to promote (see chapter 17), and you will have the undivided attention of and control over an employee.

Before you say, "I can't afford to hire someone," think again. Maybe you can't afford not to get help. In the past, you could be just a photographer and survive nicely on whatever came in the door. That is no longer true. Now, you need to be a business owner and learn to delegate the marketing and management work you don't have to do yourself.

DELEGATING TASKS

You know you can do the work yourself better, more quickly, more efficiently. Yes, but at what price? Here are the steps to follow to learn and practice the delegation skills you know will pay you back tenfold!

- Analyze the job at hand and write down all the steps. Sometimes, they are so automatic that you'll forget an important item and your marketing coordinator will not be successful. Not only is this lack of detail frustrating, it is very de-motivating!

- Decide what parts of the job you need to keep control over and what you can delegate.

- Plan the performance standards you will hold your employee to. Be sure to explain what your expectations are and what results you are looking for.

- Follow-up should be scheduled for a "reality check" to catch any mistakes or problems before they get out of control.

To hire a marketing coordinator, start with a job description. There are many tasks you can give to someone else to allow you more time and creative energy to work on self-assignments and other "business owner" responsibilities. To create a job description, write down the tasks as you go through your day that you could have delegated. They generally will be tasks that did not require your personal attention. Do this for several weeks. Then, categorize these tasks into the areas of marketing, office management, and photography production.

Here is a sample job description:

Marketing Tasks

1- Organize client/prospect database
2- Research new leads/update database
3- Organize materials for portfolios
4- Prepare materials for cost proposals
5- Manage direct mail/mailing house
6- Inventory promo pieces/publicity reprints/tearsheets
7- Keep master calendar of marketing design and production
8- Respond to requests from Web sites/ads/mailings
9- Send/return traveling and drop-off portfolios
10- Write/mail press releases

Office Management

1- Billing, bookkeeping, and filing

2- Updating vendor files and samples

3- Maintaining inventory and ordering office supplies

4- Handling stock photography filing and research

5- Answering phones!

Photography Production

1- Order and inventory film and supplies
2- Research props and background supplies
3- Test equipment on maintenance basis
4- Test cases of film
5- Shoot "tests" of models for portfolio
6- Organize and maintain location packing lists
7- Prepare, pack, and unpack location shoots
8- Pickup and shopping for props, background
9- Film processing to and from labs
10- Janitorial/maintenance

FINDING THE RIGHT CANDIDATE FOR THE JOB

Finding the right employee is critical to the success of working with a marketing coordinator. Remember, they are often your first encounter with current and potential clients. They will probably be logging cash disbursements and receipts. This is a really important and responsible position. Concentrating on the search for the right individual will pay off in the long run.

Once you have a good idea of the job description and hours required, start looking! Here's a list of places to look:

- Local colleges (business departments, of course!)

- Customer service personnel at printers, photo labs (related businesses)

- Referrals from your associations (probably the best)

- The vast and highly qualified pool of early retirees

- Share the marketing coordinator with your studio mates

For salary, you'll pay the going hourly rate for general office or administrative personnel. Check with any job placement agency to find out what is fair for your area. The greater the client contact, the more money and incentives you should create. In addition to a salary, high-level client contact can be compensated with salary plus commission. You'll find that you could hire someone for as little as fifteen to twenty hours a week at the beginning. Not

only is this more affordable, but it is easier to find part-time help among students or even retirees.

Next, talk to your accountant about becoming an employer and the financial responsibility, taxes and paperwork that will involve.

INTERVIEWING BASICS

This may be the first time you have interviewed and played the role of employer! Here are a few tips for conducting an interview. Your objective is to do the most careful job at this step to avoid potential disaster and heartache down the road.

Prepare in Advance

Be sure to use employment applications. Your local office supply store should have generic forms that you can customize. Call your local state office of labor relations and make sure that you get the information on state labor standards enforcement laws. Review the application and call and check the references. Ask "open-ended" questions such as, "What are your career goals?" not "Do you have career goals?" The state labor office will also be able to help you with the legal considerations of equal opportunity employment and questions you can and cannot legally ask.

Explain the Written Job Description

Even though you have everything in writing, discussing the responsibilities will bring out any questions now (better than later). If you run into trouble at this point, be careful about making any hiring decisions. Remember: It is a lot easier to hire someone than to fire him!

Explain How You Will Make Your Decision

Let the applicants know if you will call them or send letters. Also, give a time frame so that they don't have to keep calling you for your decision.

Take Appropriate Notes

Again, you may have state laws regulating the hiring and firing of employees that will affect your conversations and notes at the interview stage. Make sure any notes you keep will not come back to bite you!

EMPLOYEE MANAGEMENT

It will be very important from the start of your new relationship to communicate policies and practices and spell out the working relationship. Not only will this basic knowledge help your new employee to do her best work, it

will make sure the work gets done in the most efficient manner. Put together a policies and practices "manual." It should include:

1- Your mission statement and objectives as a business owner. For example, "My goal is to establish XYZ Photography as the premier portrait studio in my local market." Now everyone is working toward the same goal!

2- Employment policies such as work hours, overtime, performance reviews, vacation and holidays, sick leave, leaves of absence, injury on the job.

3- Benefits such as health insurance, disability, worker's comp, additional training.

4- Employee conduct, such as how to handle telephone calls and client contacts, work-space maintenance, and how to report problems or concerns.

Motivating Your Employees

Sometimes, you can't compensate for work above and beyond the call of duty with financial rewards. There's no question that money is motivating but it is not the only motivator. The value of recognition and attention can never be overestimated. Many employees in the clerical area look at getting into marketing as a motivator (especially if a commission is involved). Offer special training or conferences your employee might like to attend but that are not required for work. A better work environment is always an option. Be sure to ask for their multiple choices of improvements in the work space they would like to see happen. Finally, something as simple as unexpected time off is a wonderful motivation for an employee to work above and beyond the call!

Chapter 19

COMPUTERS FOR YOUR PHOTOGRAPHY BUSINESS MANAGEMENT AND MARKETING

NOT ONLY WILL YOU BE USING A COMPUTER FOR CREATING IMAGES, PHOTOGRA-phers also need to use computer programs to run a business most efficiently and effectively. Many shooters now use a separate com-puter for the business side. Software programs used for business rarely need the power or memory of the imaging programs.

If you are short on time and patience when it comes to learning what you need to know to make a smart computer purchase, hire a consultant. A consult-ant can not only help you with the initial setup, but also will be able to hold your hand through the inevitable problems and glitches. Problems are a given. No matter the choice, Mac or PC, you are buying equipment that will make your life both heaven and hell. Don't expect anything different!

GET PROFESSIONAL HELP

When seeking a consultant, look for someone industry-specific. It is help-ful if your consultant is (or was) a photographer and understands the business. However, it is not necessary, and if you find someone you have a good chem-

istry with and who is willing to take panic phone calls at 2 a.m., go for it. At least make sure he has lots of experience with your choice of platform—Mac or PC—and plenty of background in small businesses that sell professional services—that's you! Try these tips:

1 - Interview as many consultants as possible. Remember: Short-term pain (interviewing time) will always bring long term-gain (someone that will really work well with you).

2- Look for someone who knows "tech" but speaks "nontech." Though you don't want to know what they know, you want to know what they are doing to your computer and why.

3- Network through your professional peer associations for referrals. Take advantage of someone else's "hiring a consultant" learning curve.

BETTER BUSINESS MANAGEMENT

First, evaluate your type of photography business. For example, a studio shooter with lots of production-heavy assignments is more likely to benefit from materials and equipment inventory control programs than an editorial shooter who works on location. If you are planning extensive stock photography management, you will need research and captioning programs. When you work completely on your own, an integrated program that does multiple tasks would be a timesaver. For example, when you are invoicing a client, you can access his address out of the client contact database. Individual software programs from different manufacturers for each of the above functions may not talk to each other!

Second, there are the hardware and software decisions. Decide on your software needs first. The machine—the hardware—is just the equipment. The software—individual or integrated—is the real workhorse of your system. Beware of buying one manufacturer's hardware with another manufacturer's software already installed. This is a marketing trick on the part of the hardware companies to get you to buy their machine. You may not get the technical support you'll need from the software company because you didn't buy its program!

The biggest decision you'll make is whether to buy an integrated program (from $2,000 to $3,500) that will perform functions in all the areas specified below. The main advantage of an integrated program is that the information (for example, for an invoice) is accessible from within other areas of the program (such as the client database). It's not a small thing to consider. Non-integrated software programs (from $75 to $750 each) are cheaper, but then you'll find yourself doing very time-consuming tasks, such as retyping a client's name and address for each function or exiting one program just to find a client's e-mail address.

There are four major areas of software programs for your business:

- Business planning
- Marketing and selling
- Bookkeeping and accounting
- One that does it all

BUSINESS PLANNING

One important function to look for when buying software is the development of a business plan. Later (in chapters 20 and 21), you'll be writing a marketing plan for your photography business. But marketing is only one aspect of a business plan. Look for a program that includes templates for spreadsheets, production planning, goal setting, and the financial statements that are all critical aspects of business planning. This will be especially valuable should you need to approach a bank or financial institution for a loan or credit line.

MARKETING AND SELLING

Here's where your software choice is the most critical and gets the most daily use and workout. A database program is essential to organize and maintain client contact information. A word processing program that will "mail merge" with the database and print mailing labels will also allow you to send personal and custom letters for sales, quotes, and follow-up. These "contact management" programs assist with both client prospecting and maintenance by keeping track of names, addressees, contact dates, types of contacts, dates for the next contact.

You should be able to easily *search* your database for any field of information. For example, say you want to talk to everyone who is a food client you talked with in May who said to call back in September. You should be able to *sort* the information as well. In this example, a zip code sort allows you to talk to people in a geographic order. Then, when you make appointments, you are not driving from one end of town to another!

The days of the old shoebox and index cards are long gone for keeping track of information on clients and prospective clients. There are many different software programs, for both Mac and PC systems, available for contact management. Selecting the best one for you is not as easy as a word-of-mouth referral or what's on sale this week at the local software warehouse. You have to balance a purchase you can grow into with the need not to outgrow it too soon.

There are two basic directions to go with the database part of the contact management program. First, you can buy a program that has a pre-existing

client profile form and fields of information. Many word processing programs now come with their own database programs. This is great if it is your first database and you can simply input the client profile information from your index cards into the existing fields. (A field of information is anything you want to retrieve later, such as addresses, phone numbers, or dates of client contacts.) This takes less time at the front end in the setup, but is generally less flexible.

Second, you can buy a program that requires you to design the client profile form (sometimes called a "record") and specify both the fields and the layout of the form. More time at the front end in the startup, but it will be exactly what you want. Either way, with any typical database form, your client profile will look something like the following example. A colon following a word creates a "field" and allows that information to be searched sorted and retrieved.

Alpha: (allows alphabetical retrieval for firm names like John Smith
 & Company, at this field you would type "smith")
Firm:
Address:
City: state: zip:
First name: Last name:

All of the above allow for printing mailing labels or merging with a word processing program for personal letters. Keep in mind that the Postal Service requires the last line of a mailing label be the zip code, not the name of your contact!

You can also add fields such as the following:

Addl: (usually additional contact name, such as a secretary)
Phone: (always use area codes! great for sort and search)
Direct line:
Fax:
E-mail:
Web site:
Date last: (date of last contact)
Type: (type of contact-phone call? appointment?)
Date next: (date for next contact)

The following are optional fields, but they're very useful for managing the information in your database:

Job Title:

Type of client: (manufacturer? ad agency? magazine?)

Source: (research? referral?)

Product: (usually a code, such as "f" for food clients)

Project name: (for follow-up and estimating purposes)

Remarks: (where lead came from, or any other comments!)

Status: (usually a code to distinguish current vs. prospective clients)

Designing the form or record for the above "client profile" is critically important for future follow-up. Selling your photography services can be thought of simply as managing the information on what clients and prospective clients need and when they need it!

For example, the above database profile allows for the following scenarios:

- *Time Zones*: You can call prospective clients, sorted by zip code, so when you're on the West Coast, you are talking to the earlier time zones before lunch.

- *Follow-up*: You can call all clients you talked to in January who said to call back when you had a new product promo piece. You can mail new promo pieces to just the prospective clients who saw your food photography portfolio. You can mail a different promo piece to magazines and corporations. All from one form!

In addition to the contact management function (which is essential), you can look at the option of using desktop publishing software for the production of marketing materials. You can create newsletters, project announcements, copy for printed and electronic promotions, even brochures! Multimedia software programs can be used to create portfolio presentations that include video, graphics, and text with your images. Caution! Even if you do your own production, continue your relationship with a graphic designer for your marketing materials' concept and design. Let the designer help you make the most of your investment in computers and software with her expertise in these areas. Poorly produced materials will actually cost you more in lost business then the cost of working with a professional designer.

BOOKKEEPING AND ACCOUNTING

A financial software program is no longer an option; it is a necessity. The functional and labor-saving benefits far, far outweigh the learning curve on this one. Some of these functions are incorporated into integrated programs specifically designed for photography. You can also purchase financial software independent of your business software, but then the information (i.e., client names, addresses, etc.) will not carry over. Either way, what you will do with this soft-

ware can be as simple as using your business and personal checkbooks. It is just done on your computer. When you make a deposit or write a check, your screen looks exactly like your regular checkbook and checkbook register. Whether you choose an à la carte or integrated program, look for these features:

- Writing and printing all checks
- Categorizing expenses for these checks
- Recording deposits and any other transactions typical of a check register
- Reconciling checkbook in about one-fifth the time—to the penny!
- Memorized transactions for repeating the same payments
- Splitting one check into different expense categories
- Finding a transaction by keyword, check number, or date
- Net worth statements
- Profit and loss statements
- Transaction statements by category, payee, or date
- Creating budgets to track money in and money out
- Ordering bookkeeping supplies
- Preparing for tax time
- Even online banking!

One caution: If you start at any time but the beginning of your tax year, you'll have to enter all the transactions, checks, and deposits up to that point in order to be able to use the reporting and searching functions effectively. But it will be worth the effort. Not only will the reports generated from this software help you make good business decisions, you will also save hours of time every week and month on managing your finances.

ONE THAT DOES IT ALL

Finally, you can look at fully integrated software programs, combining all of the above needed functions. These programs can help you in the management of the production of photography assignments as well as your business. They are more expensive than any "à la carte" programs. But remember: The data entered once can be then used in any application. Look for these specific features if you consider buying an integrated photography management software package:

- Appointment scheduling with daily, weekly, monthly, and year-at-a-glance views
- Photo equipment inventory database

- Suppliers and vendors database
- Supplies and props inventory database
- Automatic data backup
- Stock photography management
- Client records with sales history and response tracking
- Mail merge with a word processor and print letters
- Mailing list management and labels
- Correspondence, thank-you letters, and cover letters
- Add your company logo and URL to all forms
- Project management by job and organized by due date
- Photography delivery memos
- Industry-standard photography estimate and invoice forms
- Accounts receivable and payable management
- Cost analysis for jobs that tracks costs, supplies, and rep's commissions
- Sales reports sorted by any field selected
- Profit and loss reporting function

Chapter 20

COMMERCIAL CLIENT MARKETING PLAN

YOU ALWAYS NEED TO BEGIN WITH YOUR MARKETING MESSAGE (SEE CHAPTER 2). It is the visual statement of the work you are selling. It identifies the photography work you want the photo client to remember you for when he is hiring. Given the great number of photographers to choose from, this identity or positioning in the marketplace will help the client remember to contact you and not your competition! It must be consistent throughout all print and electronic promotions.

YOUR PERSONAL MARKETING STRATEGY

Below is the outline for a typical marketing plan. It is not necessarily your marketing plan, but it is included to show you what one looks like. The outline format is recommended for several reasons. Outline form is much easier to read and review, it is easier to add to and update throughout the year, and it is less work to write!

There are two important features to the success of any plan. First, you have to break down every task into small pieces. Second, you must take these

"bite-size" tasks and cross-reference them to your daily planner. This is the key to plan the work and work the plan, and it's the key to your self-promotion success.

SAMPLE MARKETING PLAN

I. What You Are Selling-Marketing Message

 A. First, write your marketing message:

 "The Photography of Locations"

 Creating images of a location, setting, surroundings, places, buildings, environments to promote the location and to tell its story.

II. Who You Are Selling to (Identify Clients)

 A. Design Firms for high-end companies and Ad Agencies with clients in:

 Aerospace, Airline, Agriculture, Developers/architecture, Environmental, Health Care Facilities, Telecommunications, Travel/hotel/resort, Leisure and Transportation

III. How to Get the Work (Marketing Tools)

 A. Direct Mail Campaign

 1. Need designer to create concept and photography, and plan production of response mailer that will work for both ad agency clients and design firm clients

 a. Mail every six weeks

 b. Self-mailer with response card

 c. Make a strong offer for response

 d. Preferably series of single strong images

 e. Objective is to get responses from purchased mailing list to create personal database and send traffic to Web site

 f. Design mailer to be cut and bound as a mini-portfolio for multiple uses

 2. Need mailing lists that match prospective client profile

ACTIONS:

■ Find designer/copywriter team to turn marketing message into a design for mailers

■ Research purchase of mailing lists

B. Advertising Campaign

1. Objective is to impress audience with marketing message and ask for response
2. Then send more information and add to personal database
3. Need sourcebook advertising campaign
4. Need domain name and Web site

ACTIONS:

- Call annual sourcebooks for current media kit
- Meet with design team for ad and Web site design
- Select host company for Web site
- Register domain name
- Announce Web site
- Schedule Web site updates

C. Public Relations Campaign

1. Send to advertising and design clients media, photography peers and local community media
2. Plan quarterly project press releases to all media
3. Start entering awards programs for both self-assignments and published work
4. Submit self-assignments to industry publications' Awards Annuals like Communication Arts magazine

ACTION:

- Build database of all media/editors of publications, newsletters, and newspapers
- Research awards programs and annuals, and add entry dates on calendar
- Schedule press releases, and review existing projects for submission

D. Personal Selling

1. Concentrate quality time on the "Best Bets" for commercial assignments and plan monthly or bimonthly calls for follow-up
 a. Past commercial clients
 b. Past prospects for commercial work
 c. Responses to direct mail (and ads)

 d. Leads from editorial assignments

 e. Leads from mailing list above

2. **Portfolio**

 a. Continue with laminated transparency in 8 x 10" outside size

 b. Need three duplicates of each portfolio for traveling

 c. Plan subject-specific portfolios that can be pulled from, based on client of ad agency or design firm

 d. Add mini-portfolio for clients to keep on file

3. **Agents**

 a. Check on stock agency interest in this body of work

 b. Check on fine art rep interest in this body of work

4. **Promotional Materials**

 a. Buy gray folders to use with logo labels for cover.

 b. Add ad reprints and laser color copies of images along with existing publicity reprints and bio information sheet

 c. Use as a "capabilities brochure" for send-ahead and for leave-behind until budget is developed for separate eight-page brochure

ACTIONS:

- Build personal database
- Reorganize portfolios
- Redo some laminations as needed
- Order binders for travel portfolios
- Design and produce print and CD-Rom for mini-portfolios
- Research stock agencies and fine art reps
- Print promo materials

ADDING THE INTERNET TO THE MARKETING MIX

Here are some ideas for incorporating the Internet into the tools of your marketing plan. You may want to reread the chapters that discuss these different marketing tools.

- Advertising is a "nonpersonal" form of marketing designed to reach very large groups of people. It is best used when you want to broad-

cast your marketing message and have the clients call you. With print ads, you will expose thousands of people to your marketing message. With a Web page, the reach is broader in geography and larger in potential visitors to your site. Your print ads must refer clients to your Web page and your Web page must refer clients to your print ads. Use this cross-referencing to build marketing equity; don't waste any chance to build frequency with a potential client. Remember that a prospective client is looking at your site because he is looking for something he doesn't already have. Your design objective is to give clients a strong and distinct impression of your photography-marketing message and to ask them to respond. Be sure to add people who respond to your mailing list.

- Direct marketing by mail is another form of promotion very popular with e-commerce companies. Direct mail is becoming more and more sophisticated, with "call for action" copy added to your images as necessary, not optional. Don't forget about the visual impression you make! Always include your URL on your mailer and give clients a really good reason to visit your Web site after getting your mailer. Invite clients visiting your Web page to refer friends for your mailing list.

- In your public relations, be sure to list your URL as an additional method of contacting you. Mention it again in the body of the press release copy. Add a "gallery" of recently completed projects to your Web site. Then, when writing "project" press releases, add quotes from clients who refer to the Web site, where you show images from this project. All clients love to be included in any publicity and will check out your site to see their project.

- For your personal selling efforts, you can successfully integrate your Web site by making sure prospective clients have the option to visit your site to view your portfolios. They can also visit the site while talking with you. Literally, a "virtual" portfolio presentation!

Chapter 21

CONSUMER CLIENT MARKETING PLAN

VERY MUCH LIKE THE COMMERCIAL CLIENT MARKETING PLAN IN CHAPTER 20, marketing to consumers still needs to identify your marketing message, the naming of the types of clients and the outline of all four of the primary marketing tools: direct mail, advertising, public relations, and personal selling.

YOUR PERSONAL MARKETING STRATEGY

For wedding and portrait photographers, it is both a visual marketing statement and an identification of your particular subject area. Consumer clients will gravitate toward promotion that reflects their subject need (i.e., portraits might be marketed as "children's portraits" or "family portraits"). Wedding photography comes in different sizes and packages. Here again, as with commercial photography, your marketing message must be consistent throughout all print and electronic promotions.

The primary difference is the balance between the personal marketing (selling) and the nonpersonal marketing (advertising, direct mail, and public

relations). For the commercial photographer, the emphasis is on personal marketing because it is easier to identify prospective clients and knock on *their* doors. For the consumer photographer, the emphasis is on more nonpersonal marketing tools, such as advertising or direct mail. These tools "broadcast" your marketing message and bring the clients to *your* door.

Though the actions for your marketing plan will be slightly different, it still takes the same time, energy, money, and attention. You will just spend these resources differently in the attention you give to personal as opposed to nonpersonal marketing.

Be sure you break down every task into small enough pieces. Then, cross-reference them to your daily planner. Once again, *plan the work and work the plan!*

THE ART OF CONSUMER CLIENT MARKETING

Here is a presentation by David G. Rigg on the art and the science of consumer client marketing for any wedding and portrait photographer.

David says, "First, get a truckload of money . . . Seriously, I don't think we would be giving anyone the bad news if we reiterated the undeniable fact that it takes money to make money! That is rule #1 in marketing. There may be exceptions to every rule, but you are not it. Marketing is an upfront investment. The marketing budget is a matter of simple math. After establishing your personal goals and requirements, and figuring a "breakeven analysis," the overall consumer client marketing budget will be somewhere between 8 and 15 percent of gross sales. Due and payable now, please. Why such a wide range? Because the structure, market position, and maturity of your business will determine the amount needed for effective marketing.

"A storefront studio with thousands of drive-by exposures per day will budget and allocate expenditures much differently than a residentially based operation. The new kid on the block has to market to prospect lists, while the older, more established studio can mine its own databases for new business.

"Before a client will consider making a major investment with your studio (and your portraits had better represent a major investment by the client if you expect to stay in business; don't think you can just jump in and undercut the market), you must establish name recognition. Name recognition is the process of taking a prospect from total apathy to a comfort level with your marketing message. Repetition is the key to this process. I have seen research that shows it takes a minimum of nine solid exposures to a marketing message to bring the prospect to a comfort level with your marketing. Here is the key though: Humans can only retain about a third of what we see and hear; therefore, your prospect is going to have be exposed to the message at least twenty-seven times!

"This frequency needs to be the core of every decision you make with regard to timing and budget.

"When I say expose them twenty-seven times, I don't mean with the exact same vehicle. Your knowledge of your target prospect will allow you to get the frequency you need in a variety of ways. When your client says, 'We see your portraits and ads everywhere,' you know you have selected the right vehicles for that demographic. You can use display advertising to supplement the overall campaign, but only if it's appropriate and cost effective.

"My preferred tool of choice is direct mail. Eighty percent of our entire marketing budget goes to this particular vehicle.

"Also, I hope this goes without saying, but you can't stop after twenty-seven exposures; marketing is a never-ending cycle; someone may have just gotten on the merry-go-round at twenty-four! Your expectations for your marketing must also reflect that the portraiture business is seasonal. With the fourth and second quarters of the year representing the majority of portrait sales, and the major marketing expenditures generally occurring in the first and third quarters, you may have some cash flow considerations to deal with as well. A flexible and large enough line of credit could very well make the difference between struggle and success.

"You must also consider the available marketing tools for reaching your target audience. Smaller geographic markets may have fewer options for carrying your marketing message. Larger markets have more options, but your message may become diluted by the sheer volume of marketing that reaches your client demographic."

So, much like the commercial photographer does, David is recommending that you identify your type of photography (target market), identify the clients (target demographic) and then plan how you will reach them. You will use "broadcasting" tools (such as direct mail) and plan on frequency of contact ("hits") to develop the recognition that brings response. It is client response that brings the work and success with your self-promotion.

Chapter 22

YOUR TURN—
FINAL TIPS

WHETHER YOU ARE SELLING STOCK PHOTOGRAPHY, WEDDING AND PORTRAIT, OR commercial photography, there are considerations and factors that all potential clients need to know before they make the big decision to work with you! Check these final tips against your marketing plan and self-promotion materials and make sure you have them represented.

WHAT YOUR PHOTOGRAPHY CLIENTS ARE REALLY LOOKING FOR

Photography marketing and self-promotion are about how well potential clients get to know you and what you can do for them. So, we conclude with a list of factors that will help answer the little voice inside every photographer that says, "I'm good. Why can't clients just call me?" Your self-promotion needs to reflect what clients really need to know about you. This personal knowledge about you is necessary because all of the clients you are selling to already have photographers they work with.

When you add these factors to your sales presentations, advertising, direct mailing campaigns, and promotional materials, you help clients move you from the vast pool of photographers they have seen to the smaller pool of photographers they would consider calling when they have work. This is your highest objective in marketing—to get yourself on "the short list," literally, the short list of photographers called for work.

PHOTOGRAPHIC ABILITY

This is almost a "given" in today's new marketplace for photography services. It is clearly seen in your work, but at the same time, there are a lot of technically competent photographers. When you have a hidden technical capability, it should be brought out to give you a competitive edge.

GIVE THE CLIENTS WHAT THEY WANT

A tricky subject. Lots of photographers would like to show their highest level of creative ability in their portfolios. Unfortunately, lots of clients don't have the time, budget, or creative aesthetic to use it! Before you put together your next sales presentation, be sure to determine whether your client is interested in creative collaboration or a preconceived image fulfillment. This can be confusing, because many photographers are not clear about the distinction between the two types of clients. Neither is wrong or bad, but they are very different.

The client who buys creative collaboration looks at style, personal vision, and the way you see things. It could be the bride who wants a "different" look for her wedding photos. It could be the product client who wants a background that has never been seen before.

The image fulfillment client wants to see what he is hiring you for before you shoot it or he wants the "straight" shot. This has been called the "red shoe syndrome": The photographer who shows any other color shoe in her portfolio will not get the job because the client figures she can't shoot red shoes if she doesn't show red shoes. Simply know whom you are talking to when you present so you can show the appropriate portfolio.

MAKE THEM LOOK GOOD

This is a very difficult subject for clients to discuss openly. Your best bet is to be very aware of how sensitive clients are to how the photos (stock or assignment) will make them look. This awareness is a potential competitive edge and added value to your photography. To prove your awareness, add "case study" anecdotes of client testimonials when marketing yourself. You will

have a better chance of making the leap to the short list. Remember: This leap is made when prospective clients can visualize themselves successfully working with you. Help them with stories of your work with other clients or your work on a public service project. Help the client become the hero.

CREATE THE PERCEPTION OF EFFORTLESSNESS

Every client's dream photography project is the one that eases his frustrations and meets his challenges. Your marketing should address this issue because every client is thinking of it whether he admits it or not. In addition, it provides a counterpoint to the client's objection, "We're happy with our current photographer." There is always something the current photographer has done to frustrate the client or make a shoot or stock photo purchase difficult. This could be your way "in the door."

BE FLEXIBLE

This means you will be easy to work with and solve problems, not make more than your clients already have. Whether it is a wedding or a catalog shoot, no client needs more problems! The problem with many of the desirable qualities listed here is that they are difficult to demonstrate to the client until the client has worked with you. For example, how will the prospective client get to know that you are flexible until he's worked with you, but he won't give you a job until he knows you are flexible? The answer is to demonstrate flexibility in *every contact* you have with a client. Plan it into your marketing strategy. Starting with the first phone call and through your first job with him. Remember: You are must demonstrate your flexibility before you work together in order to get the job in the first place. The best evidence of your flexibility will be offering references or testimonials from other clients in your promotional material. You can tell someone you're flexible, but a third party has more credibility. By the way, flexibility does not mean dropping your price to get the job.

WORK WITHIN DEADLINES AND BUDGETS

Again, the case study approach in your sales presentations and client testimonials is the best way to demonstrate this very important quality. Think about it: Can a client tell the photo shoot came in at budget and by deadline by just looking at your work? No! You've heard the old saying, "The portfolio speaks for itself"? It does speak to your creative and technical ability but it does not speak to your working relationship with a client.

Failing to meet a budget or deadline is most likely to happen on the first job together, so always ask what the clients' concerns or restrictions are for a

project. It's better to assume they have some! Be very specific with your questions. Instead of asking, "Do you have a budget concern?" ask, "What are your budget concerns?" You can't always get an exact answer, but you will get enough information to make a good guess. A good way to demonstrate this intangible quality is through testimonials and references. You can bring this point up during your portfolio presentation. For example, you can mention how satisfied the client was on a specific portrait shot because you were able to soothe all the different personalities in the family and make the image come together. Another example: Mention the client's satisfaction with your delivery time and cost control. Don't say things like, "Here's an eight-page brochure I photographed;" they can see the obvious. Talk about what they can't see-time and money management.

CAN THEY TRUST YOU?

Being able to trust you and know your work together is confidential is very important.

You can demonstrate your trustworthiness with your presentations. Some ways to do this are: not speaking badly about other clients you have, not putting down your competition, not having another client's work lying around in full view when a prospective client visits the studio. Above all, make sure you consult with a client before using her image or product in any of your self-promotion. Yes, you own the copyright to your photos but the client, in turn, owns the trademarks and patents on the products!

HOW WILL YOU HELP CLIENTS DO THEIR JOBS?

Time is money. A clear competitive edge can be gained when you can demonstrate to your prospective clients that they can be more productive or profitable because they work with you. Again, case studies and client testimonials make for good demonstrations and additions to your marketing plan. Like most of these factors, you need to learn to sell yourself. You need to help the client hire you!

PHOTOGRAPHERS INTERVIEWED FOR THIS BOOK

Spencer Awes, Managing Partner, Vubox

(707) 748-4291 (phone and fax)
www.vubox.com
spencer@vubox.com

Randy Becker, Elite Photo Graphics, Inc.

3230 W. Hacienda Ave., Ste. #302
Las Vegas, NV 89118
(702) 597-2822 (phone)
(702) 597-2833 (fax)
www.elitephotographics.com
elite@lasvegas.net

John Blair, John G. Blair Studio

848 North Allen Ave.
Pasadena, CA 91104
(626) 798-3962 (phone)
www.jgblairphoto.com
info@jgblairphoto.com

J.W. Burkey, D Squared Studios, Inc.

2507 Texas Plume Road
Cedar Hill, TX 75201-8201
(972) 291-8005 (phone)
(469) 272-0595 (fax)
www.jwburkey.com
jwburkey@jwburkey.com

Nancy Clendaniel, Clendaniel Photography

11545 SE 175th Street
Renton, WA 98055
(425) 277-6507 (phone)
(425) 204-8949 (fax)
www.clendanielphotography.com
nanclendan@aol.com

Ken Dorr and Mario Marchiaro, Kenario

236 Portal Ave. #502
San Francisco, CA 94127
(415) 664-6811 (phone)
(415) 682-7006 (fax)
www.kenario.com
photography@kenario.com

Michael Furman, Photographer

115 Arch St.
Philadelphia, PA 19106
(215) 925-4233 (phone)
Michael@ergo-mfp.com

Ira Gostin, Gostin Photography

Location People Photography for Corporate & Advertising
316 California Ave., Ste. 96
Reno, NV 89509-1650
(775) 333-9173 (phone)
www.gostinphoto.com
ira@gostinphoto.com

Mark and Lisa Graf, Graf Photography

12611 Beresford Drive
Sterling Heights, MI 48313
(810) 323-0794
www.grafphoto.com
grafphoto@earthlink.net

John Kieffer, Kieffer Nature Stock

4548 Beachcomber Court
Boulder, CO 80301
(303) 530-3357 (phone)(303)530-0724 (fax)
john@kieffernaturestock.com

Henry Lehn, Aspect Ratio Design

6422 Homewood Ave.
Hollywood, CA 90028
(323) 957-4055 (phone)
(323) 463-8134 (fax)
www.lehnphoto.com
hankipat@earthlink.net

Tony Luna and Harry Liles, New Media Marketplace

819 North Bel Aire Drive
Burbank, CA 91501
(818) 842-5490 (phone and fax)
www.newmediamarketplace.com
tony@newmediamarketplace.com

Shawn Michienzi, RIPSAW, Inc.

1625 Hennepin Ave. South
Minneapolis, MN 55403
(612) 673-0594 (phone)
(612) 673-0531 (fax)
www.ripsaw.net
ripsaw@ripsaw.net

**Michele Miller and Dimitri Spathis,
Spathis & Miller Photography**

801 Minnesota Ave., Ste. 10
San Francisco, CA 94107
(415) 647-9316 (phone)
(415) 643-4823 (fax)
www.spathismiller.com
studio@spathismiller.com

Julie Diebolt Price, JDP Photography

10381 Prather Lane
Tustin, CA 92782
(714) 669-4537 (phone and fax)
www.jdpphotography.com
jdpphoto@earthlink.net

Seth Resnick, Seth Resnick Photography

28 Wolcott Road
Chestnut Hill, MA 02467
(617) 277-4920 (phone)
(617) 277-4921 (fax)
www.sethresnick.com
sethres@sethresnick.com

David G. Rigg, F-PPC, PPA, Director of Marketing, **Sandra David Fine Art Inc.**

508 East Howard Lane #333
Austin, TX 78753
(512) 350-7332
www.SandraDavid.com
David's Web site: www.SimplytheFinest.com
DavidR@SandraDavid.com

Al Satterwhite, Satterwhite Productions, Inc.

P.O. Box 398
Concord, VA 24538
(310) 305-1818 (phone)
www.alsatterwhite.com
avsfilm@earthlink.net

Karen Gordon Schulman, Focus Adventures

555 Pamela Lane/P.O. Box 771640
Steamboat Springs, CO 80477
(970) 879-2244 (phone and fax)
www.focusadventures.com
focus22@excite.com

Stan Sholik, Stan Sholik Photography

1946 East Blair Ave.
Santa Ana, CA 92705
(949) 250-9275 (phone)
(949) 756-2623 (fax)
www.stansholik.com
stan@stansholik.com

Morgan Shorey, The List Inc.

375 Pharr Road, Suite 211
Atlanta, GA 30305
(404) 814-9969 (phone)
(404) 261-4465 (fax)
www.thelistinc.com
morgan@thelistinc.com

Zave Smith, Zave Smith Photography

1041 Buttonwood St.
Philadelphia, PA 19123
(215) 236-8998 www.zavesmith.com
saves@erols.com

David Sutton, Sutton Studios

1532 Crain St.
Evanston, IL 60204
(847) 328-0346
www.suttonstudios.com
Suttons@enteract.com

Stephen Webster, Photographer

World Wide Hideout
3199 Indianola Ave.
Columbus, OH 43202
(614) 262-0500 (phone)

(614) 262-0555 (fax)
www.worldwidehideout.com
stw@worldwidehideout.com

Richard Weisgrau,
Executive Director, ASMP

150 N. Second St.
Philadelphia, PA 19106
(215) 451-2767 ext. 1201
(215) 451-0880 (fax)
www.ASMP.org
weisgrau@asmp.org

INDEX

BOOKS FROM ALLWORTH PRESS

How to Shoot Stock Photos that Sell, Third Edition
by Michal Heron (paperback, 8 x 10, 224 pages, $19.95)

Pricing Photography: The Complete Guide to Assignment and Stock Prices,
Third Edition by Michal Heron and David MacTavish (paperback, 11 x 8½
160 pages, $24.95)

Business and Legal Forms for Photographers, Third Edition
by Tad Crawford (paperback, with CD-ROM, 8½ x 11, 180 pages, $29.95)

ASMP Professional Business Practices in Photography, Sixth Edition
by the American Society of Media Photographers (paperback, 6¾ x 10,
416 pages, $29.95)

The Photographer's Internet Handbook, Revised Edition
by Joe Farace (paperback, 6 x 9, 232 pages, $18.95

Photography: Focus on Profit by Tom Zimberoff (paperback, 6¾ x 9⅞,
416 pages, $35.00)

**Re-Engineering the Photo Studio: Bringing Your Studio into
the Digital Age** by Joe Farace (paperback, 6 x 9, 224 pages, $18.95)

The Photographer's Assistant, Revised Edition by John Kieffer
(paperback, 6¾ x 9⅞, 256 pages, $19.95)

Mastering the Basics of Photography by Susan McCartney
(paperback, 6¾ x 10, 192 pages, $19.95)

Travel Photography, Revised Edition by Susan McCartney
(paperback, 6¾ x 10, 360 pages, $22.95)

The Photojournalist's Guide to Making Money by Michael Sedge
(paperback, 6 x 9, 256 pages, $18.95)

Mastering Black-and-White Photography: From Camera to Darkroom
by Bernhard J Suess (paperback, 6¾ x 10, 240 pages, $18.95)

**Historic Photographic Processes: A Guide to Creating Handmade
Photographic Images** by Richard Farber (paperback, 8½ x 11, 256 pages, $29.95)

Photography Your Way: A Career Guide to Satisfaction and Success
by Chuck DeLaney (paperback, 6 x 9, 304 pages, $18.95)